SALE
THROUGH TIME
Steven Dickens

AMBERLEY PUBLISHING

About the Author

Steven Dickens has a BA (Hons) in History (Sheffield University) and an MA in Twentieth-Century History (Liverpool University), and is a retired charge nurse and college lecturer. He has previously written for several local history publications, genealogy journals and magazines. Steven lives in Flixton and is married to Sarah. They have three sons and three daughters.

First published 2013

Amberley Publishing
The Hill, Stroud
Gloucestershire, GL5 4EP

www.amberley-books.com

Copyright © Steven Dickens, 2013

The right of Steven Dickens to be identified as the Author of this work has been asserted in accordance with the Copyrights, Designs and Patents Act 1988.

ISBN 978 1 4456 0908 9

British Library Cataloguing in Publication Data.
A catalogue record for this book is available from the British Library.

Typeset in 9.5pt on 12pt Celeste.
Typesetting by Amberley Publishing.
Printed in the UK.

Introduction

The place name Sale has its origins in the Anglo Saxon word *Sealh*, meaning Willow, or the place where the Willow grew. This particular species of tree grew in abundance close to the River Mersey, upon whose southern bank Sale is situated. Its proximity to the river continued to affect the lives of Sale residents until relatively recent times. During the late nineteenth and early twentieth centuries Sale's population and economic importance grew rapidly, reflected in the number of images available in this period. However, by 1974 the town became administratively a district of the Metropolitan Borough of Trafford and although a suburb of Manchester, spiritually it still remains in the county of Cheshire.

The main influence in Sale remains the Roman Watling Street, now the A56 Cross Street and Washway Road. This was the Roman Army's route out of their fort of Mamucium, at Manchester, from which they would march in a south-westerly direction towards Condate, at Northwich, and the Roman fort of Castra Deva, at Chester. Similarly, they would march in a northerly direction, via Rigodunum, or Castleshaw, over the Pennines, to Mamucium's equivalent fort, at Eboracum, in York. Throughout history Watling Street has remained an economic lifeline for the area, allowing trade to pass through to local markets in Manchester, Chester, Cheshire and nationally. It was also a droving route for livestock, until the advent of the railways. Despite alternative forms of transport it continues as a busy main road, feeding into the motorway network – the M6, M56, M60 – and Manchester airport, and as such figures extensively in this study. While I have made every effort to provide a consistent representation of the whole area, inevitably some districts will have more coverage than others. This is simply as a result of those images which have been made available to me and reflects the standpoint of previous historical researchers on the relative importance of particular locations.

The book has been divided into five 'districts', which are approximately equal in area and can be studied individually, if preferred. The first section begins at Crossford Bridge, on the Sale boundary with Stretford, which is also the county boundary between Cheshire and Lancashire, and takes the reader along Cross Street and onto Washway Road. The next section begins at the Marsland Road junction with Washway Road and takes in Sale and Brooklands Cemetery, Brooklands station, Brooklands Road, and ends at Marsland Road, in Sale Moor. The third section begins on Northenden Road, at Sale Moor, continuing out of the town centre, taking in Old Hall Road before heading back towards Sale Moor, in the direction of Sale and including Trinity Methodist chapel, St Anne's church and Sale (Worthington) Park. Continuing towards Sale, the town hall and the retail sector, along School Road, form the next district, ending at School Road's busy junction with Cross Street, Washway Road and Ashton Lane. The final section is the Ashton on Mersey area, which became a part of the district of Sale after its amalgamation in 1930.

My own links to Sale are extensive, with three generations of my family born and brought up at Orchard Place and Hereford Street, both on School Road. Extended family also lived on Northenden Road, until the Luftwaffe's bombing raids of 1940 led to their relocation to Palmer Street, until the late 1960s. Therefore, I have been fortunate enough to have had a great deal of research input from my immediate family members, for which I am most grateful.

Nationally, 2012 was the year in which Queen Elizabeth II celebrated sixty years as our reigning monarch and the Olympic Games came to our shores. It was also notable for being one of the wettest years since records began in 1910, with natural sunlight at a premium in many of my photographs! Inevitably, the physical fabric of the town has changed and I trust that my endeavours in the following pages have represented them adequately. However, it has not been possible, at all sites, for a modern photograph to be taken from exactly the same place as its counterpart, so the nearest acceptable alternative location has been chosen where this is the case.

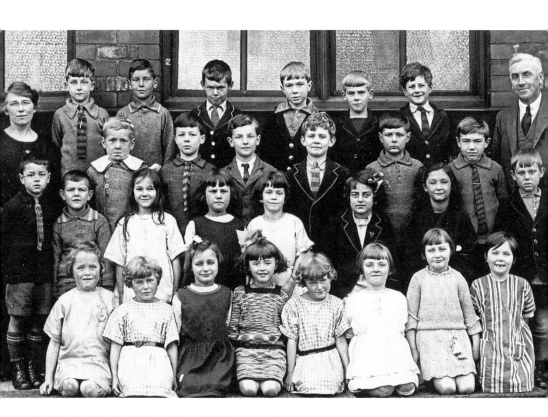

St Mary's School, St Mary's Road, Ashton on Mersey, c. 1930
St Mary Magdalene Higher Grade School opened in 1896, at the same time as the parish of St Mary Magdalene was officially established. The new parish satisfied the need for a second church to serve the Ashton on Mersey district and coincided with huge population growth in the area, as more suburban housing was constructed. Also, Springfield Council School opened in 1907, replacing the nearby Sale Township School, established in 1800 and after which School Road took its name.

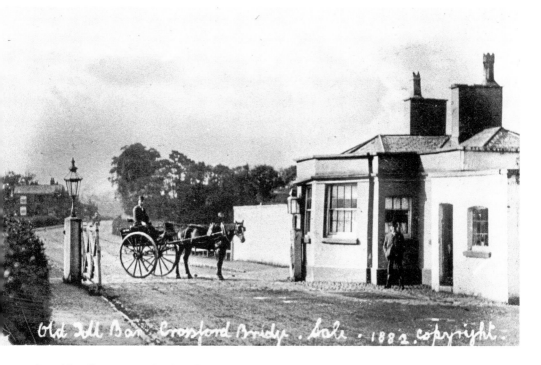

Old Ill Bar Crossford Bridge . Sale . 1882. copyright .

The Old Toll Bar, Crossford Bridge, 1882

The toll-house at Crossford Bridge was built in 1765, on a much narrower Chester Road, which was widened in 1961. It was situated where the bus shelter now stands in 2012. This was just inside the Ashton boundary, next to the Bridge Inn, Stretford. The Crossford toll bar was abolished on 31 October 1885, with the Bridge Inn being demolished in the 1980s. The whole area is now the site of T.G.I. Friday's, seen on the right of the 2012 photograph.

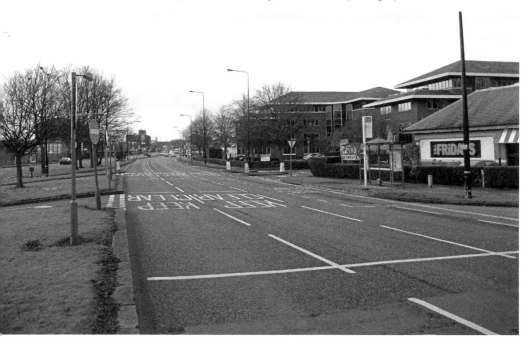

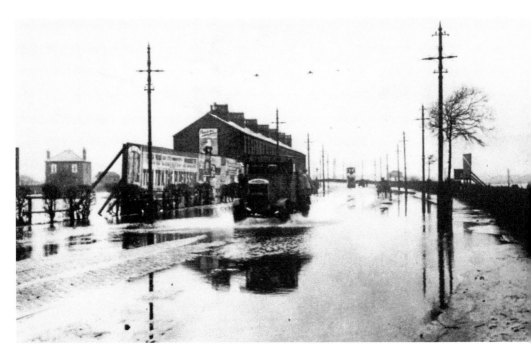

The River Mersey, Crossford Bridge, and the A56 Chester Road, Sale, 1910
Crossford Bridge carries the A56 Cross Street over the River Mersey and is first referred to in 1538. The bridge, rebuilt in 1578, was destroyed in 1745 to delay the Jacobite advance. In 1907 it was widened and in 1961 the height of the parapets was increased, when the steel bridge was erected to carry south-west-bound traffic, shown in the foreground of the 2012 photograph. In 1910 Albany Terrace, demolished in 1984, was on the site of T.G.I. Friday's.

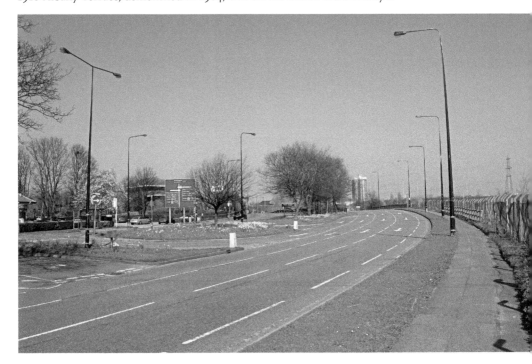

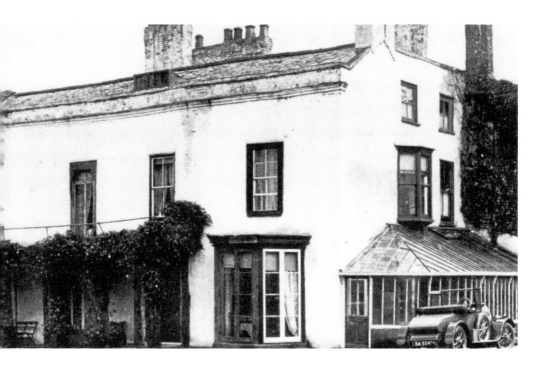

Dane Road–Sale Priory, 1922, and White's Bridge, 2012

Sale Priory was never used for religious purposes, being intended for private occupation. It was once the home of Doctor Charles White, who kept the embalmed body of Hannah Beswick at the priory. Hannah's fear of being buried alive led to her body remaining at the house for one hundred years. The priory was demolished in 1932, although the nearby White's Bridge is named after the family. Priory Gardens and Lynn Avenue were once part of the property's grounds.

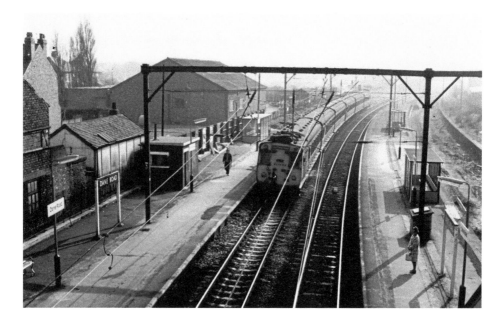

Dane Road Railway and Metrolink Station, 1971

Dane Road (Sale) opened as a railway station on 20 July 1931 and closed on 24 December 1991, converting to a Metrolink tram station on 15 June 1992. It was originally a four platform railway station, until 1963, when it was reduced to two platforms post-Beeching Report. It is located on what was the Manchester, South Junction & Altrincham Railway, terminating at Altrincham. It was opened two months after electrification, which increased the capacity of the line's rolling stock.

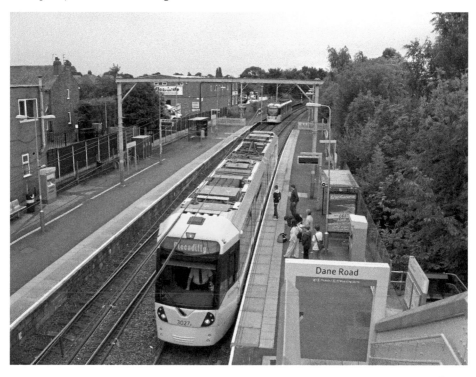

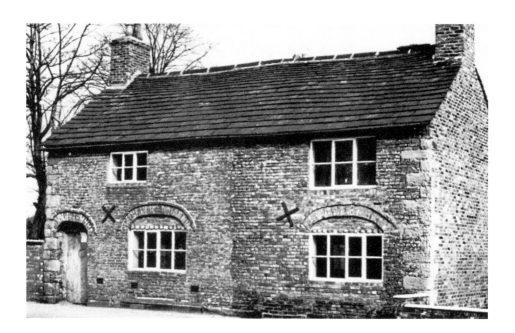

Eyebrow Cottage, Cross Street, *c.* 1900

The oldest building in Sale and one of the earliest brick-built buildings in the area, Eyebrow Cottage was a Yeoman's farmhouse around 1670. In 1806 it was the home of Captain John Moore, who raised the Sale Volunteers in 1803. The distinctive sills above its windows gave the cottage its name, being designed to deflect heavy rainfall in bad weather. In the seventeenth century the area of Cross Street where Eyebrow Cottage stands was a separate village from Sale.

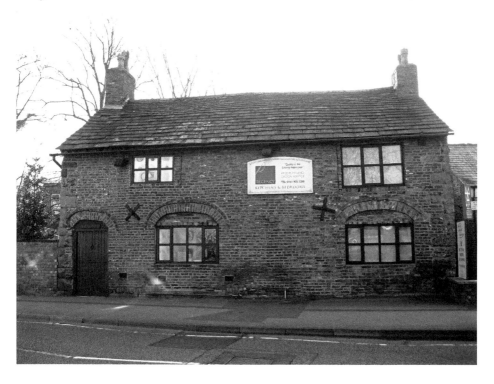

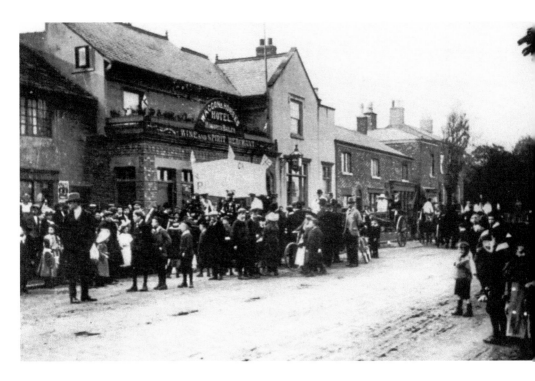

The Waggon & Horses, Cross Street, 1902

The Waggon & Horses public house has been closed for about a decade, deteriorating beyond repair, even though it is situated on a prime development site. Despite this location, it is unlikely to be restored and remains a monument to the town's historic past. Photographed in May 1902, the Waggon & Horses is shown in more prosperous times, with Howorth Bailey the landlord and the parade of an ox roast to celebrate the end of the Boer War.

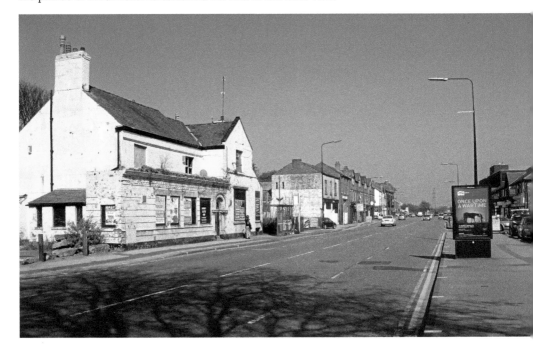

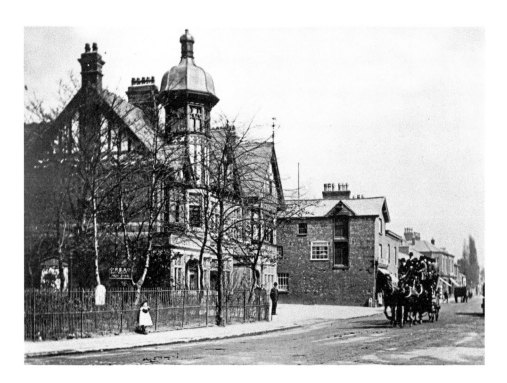

The Volunteer Hotel, Cross Street, 1905

The Volunteer Hotel opened in 1898, replacing the White Lion, which stood here from 1807 and had been renamed by 1827. The name originates from the Ashton on Mersey and Sale Loyal Volunteers, raised in 1803, at the Plough Inn, Ashton on Mersey. The building next to the Volunteer in 1905 was originally a hayloft and then a grocer's shop. Now surrounded by office blocks, in 1898 the Volunteer's distinctive tower was a dominant point on the Sale landscape.

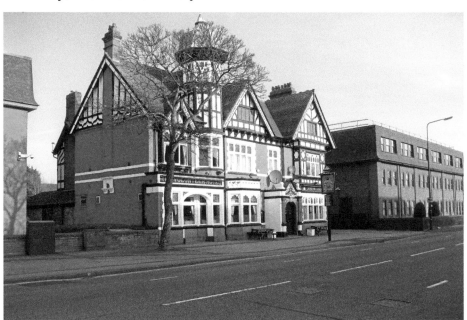

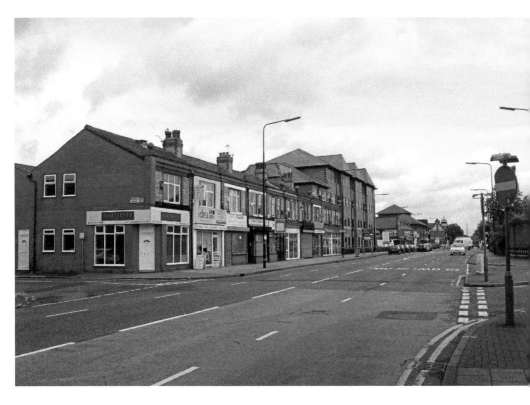

Cross Street, c. 1930
In 1930 Eden Place, at its junction with 24 Cross Street and on the right of the photograph, was the site of a row of shops, which have been replaced by an extensive retail development in 2012. The row of shops on the left remains, with the addition of a large office block at its far end by 2012, and in the distance the distinctive tower of the Volunteer public house, still recognisable today, can just be made out.

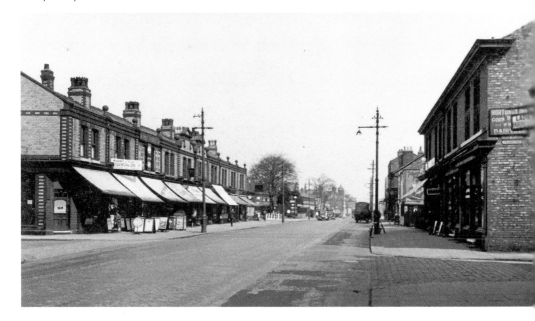

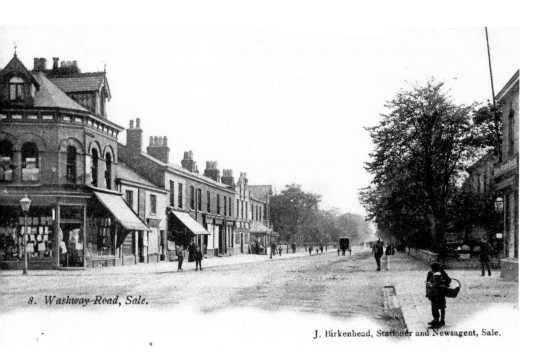

8. Washway Road, Sale.

J. Birkenhead, Stationer and Newsagent, Sale.

Cross Street, Looking Towards School Road, Washway Road, and Ashton Lane Junction, 1903
School Road is to the left on these photographs, with the Bull's Head Hotel just off camera. Washway Road heads towards Altrincham and the provisions store of John Clarke can just be seen on the extreme right of the photograph dating 1903, where there is a gaslight. Trees shroud the premises of John Ingham & Sons, photographers, where Ashton Lane forms the corner of Washway Road. In 2012 pedestrian crossing lights control traffic at this very busy junction.

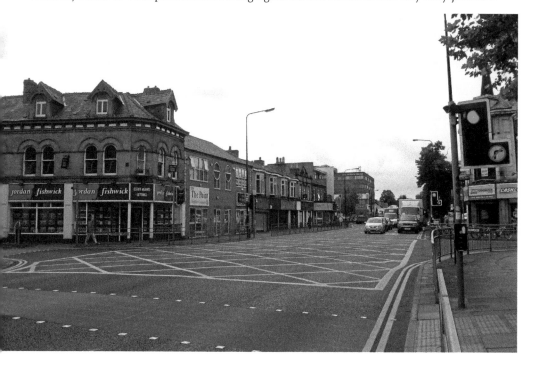

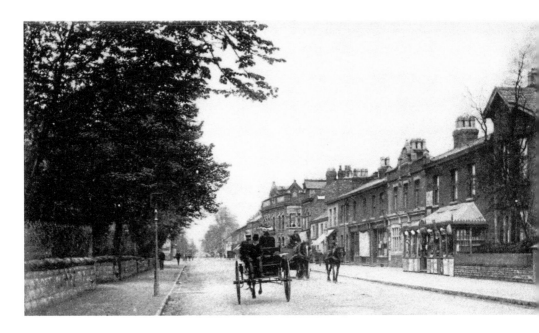

Washway Road, Looking Towards School Road, Cross Street, and Ashton Lane Junction, 1903
The Bull's Head Hotel continues to dominate the junction of Washway Road, Cross Street, Ashton Lane and School Road, with the retail premises on the right side of the photograph now replaced by a modern development. Originally they housed the business concern of John Birkenhead, stationer and newsagent, whose photographic record of the area is of immense value to local historians. The left side of the photograph shows the perimeter of John Ingham & Sons, photographers, near Ashton Lane junction.

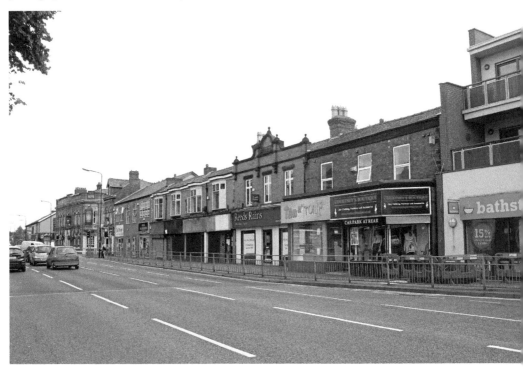

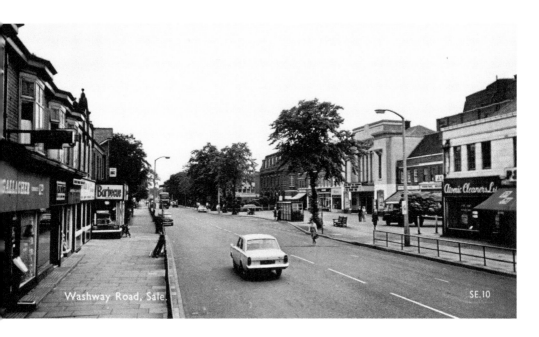

Washway Road, Looking Towards Altrincham, 1965

On the left of the 1965 photograph, the original terrace can be seen, which once housed the retail premises of John Birkenhead, stationer and newsagent, and later became a post, sorting and telegraph office, until 1931. To the right of the photograph is Washway Parade and the Odeon cinema, now a fitness club, with the old post office between the trees in the centre. This post office opened on 20 September 1931, despite some initial opposition from local traders.

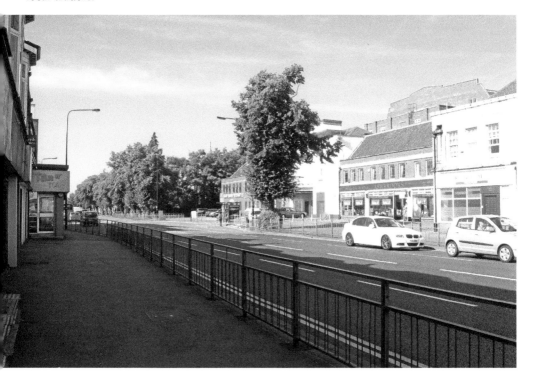

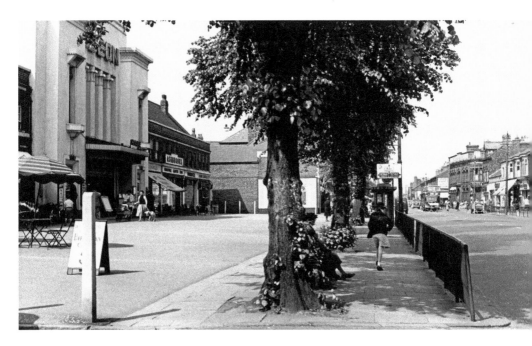

The Odeon Cinema, Washway Road, Looking Towards Cross Street, 1955
Built in 1933 and originally named the Pyramid cinema, the Odeon closed in October 1981. The row of trees and benches, which dominates the 1955 photograph, has gone by 2012, although a modernised bus stop remains. Ashbrooks furniture store, a family concern established in 1889, is still retailing here in 2012. The 1955 photograph has café seats and umbrellas in front of the Odeon cinema, whereas its 2012 equivalent has a row of cars – probably customers of the fitness club.

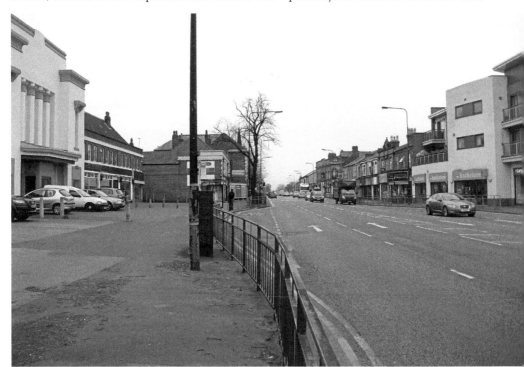

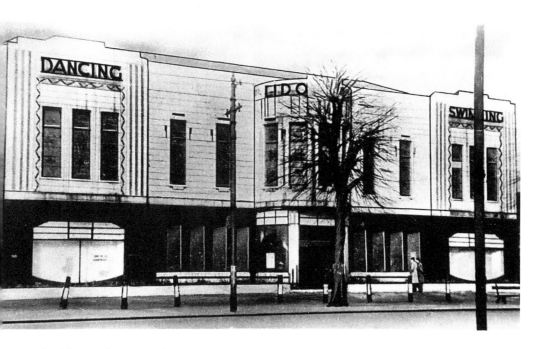

Sale Lido, Washway Road, 1940

Opened on Wednesday 10 July 1935, by Mr J. Harcourt Wilson, Chairman of Sale Urban Council, its 130-foot (39.6 metres), 160,000-gallon pool could be covered and used as a dance floor, and there was also a domed solarium, making Sale Lido one of the most modern buildings of its time. It was built in green and cream terracotta tiles and was part of a complex that included a row of shops. Mecca Ltd renamed it the Locarno Ballroom.

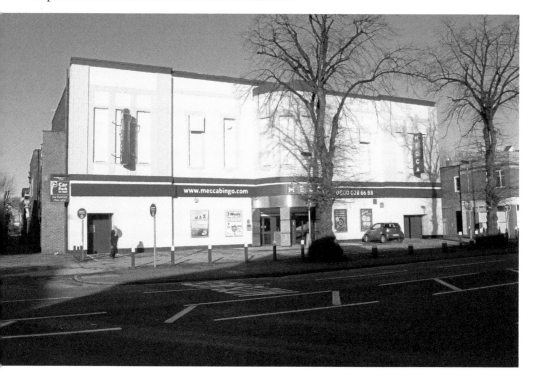

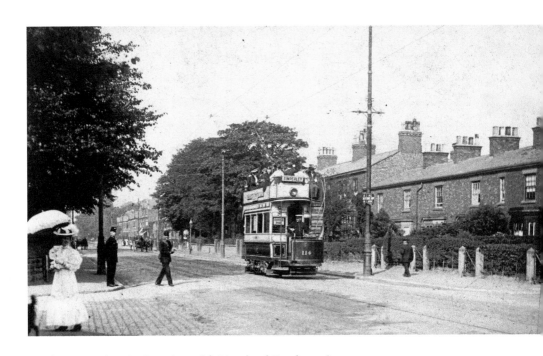

Washway Road, at its Junction with Marsland Road, 1906
The year 1906 is significant, because on 17 August of this year the tramline to West Timperley was officially opened to the public. Originally the tram service ran from Manchester to Stretford, and was extended to Sale and eventually to Altrincham by 1907. The destination of 'Timperley' can be clearly seen on the front of the tram, while a policeman patrols this busy junction. The trees behind the tram remain in 2012, although the cottages have now been demolished.

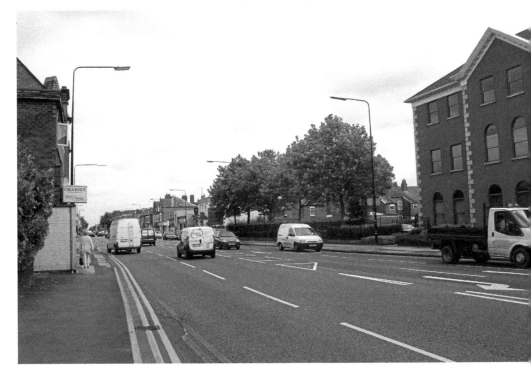

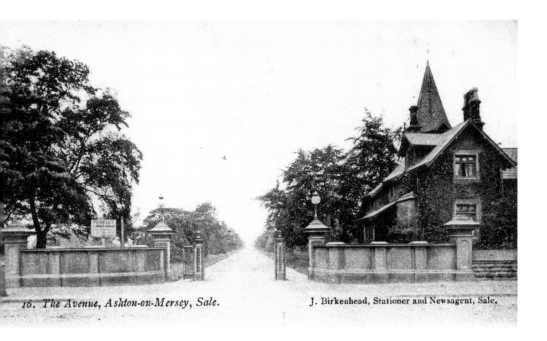

16. *The Avenue, Ashton-on-Mersey, Sale.* J. Birkenhead, Stationer and Newsagent, Sale.

Washway Road, at its Junction with the Avenue, 1903

The Avenue was deliberately built long and straight, the intention of this being to bring the rural countryside of Cheshire into the urban heartlands of Sale. At its junction with Washway Road is a gate and lodge, which was home to a gatekeeper, serving the mansions of Oakleigh, Woodheys Grange and Ashleigh. The lodge still has its spire in 1903, which acted as a local landmark at this time but unfortunately it is no longer standing in 2012.

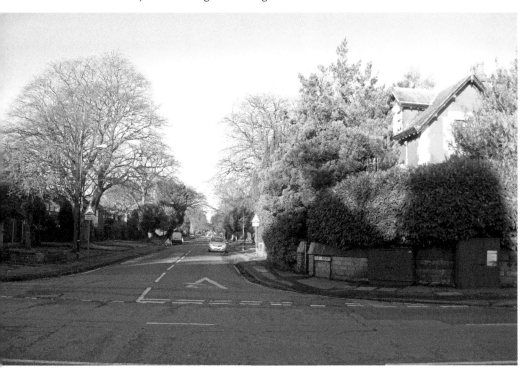

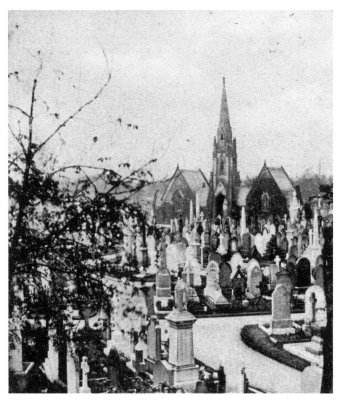

Sale and Brooklands Cemetery, Marsland Road, *c.* 1900
Sale and Brooklands Cemetery opened in 1862 and stretches across both sides of Marsland Road, being linked by an underground tunnel. The north side of the cemetery is older and houses a chapel, shown in the photographs. It was the first public cemetery serving the south of the Manchester conurbation, with many notable families buried here. The scientist, James Prescott Joule; Richard Pankhurst, of the suffragette family; Edward Hulton, the newspaper magnate; and Samuel Lord, all have their memorials here.

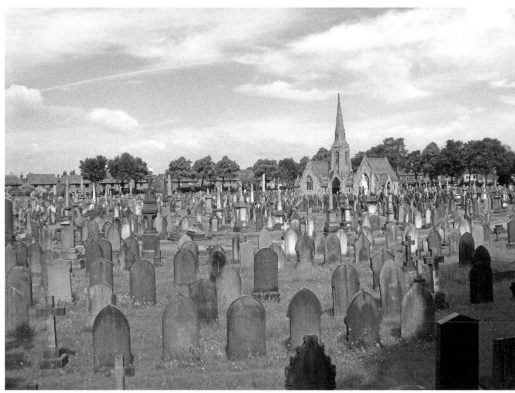

The Brooklands Hotel, The Woodcourt Hotel, Shops on Brooklands Road, Framingham Road, and the Brooklands Hotel from Marsland Road, 1954

Marsland House now occupies the site of the Brooklands Hotel, demolished in 1972, with the Woodcourt Hotel also demolished. The photograph of Marsland Road looks towards Sale and the Brooklands Hotel, at its junction with Hope Road on the right and Brooklands railway station, at its junction with Brooklands Road, on the left. The shops and Walton Park also form part of this junction, on the left of Brooklands railway station. In 2012 there are traffic lights at this crossroads.

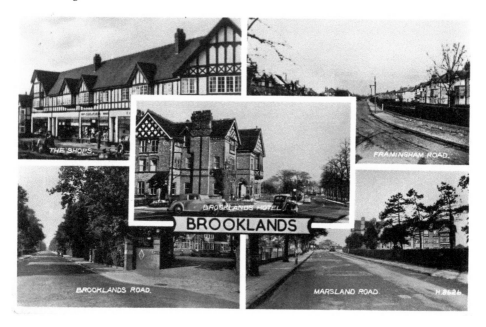

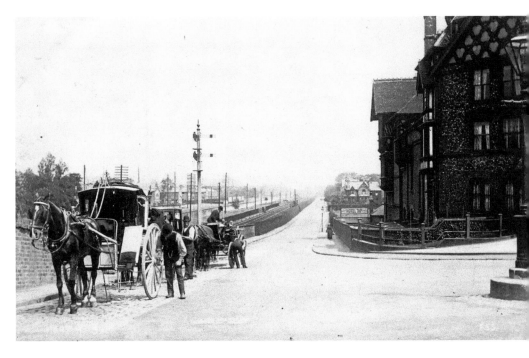

Horse Taxi Rank, at the Junction of Marsland Road and Hope Road, 1904

Horse-drawn transport was still prolific in 1904 and the horse taxis on the left are awaiting custom from the Brooklands Hotel, seen on the right, and Brooklands railway station, behind the photographer. Hope Road heads towards Sale; to the left is the railway line, signal and the Bridgewater Canal. Beyond the brick wall, next to the horse taxis, is Sale and Brooklands Cemetery. The Brooklands Tap public house, once a separate part of the hotel, survives next to Marsland House.

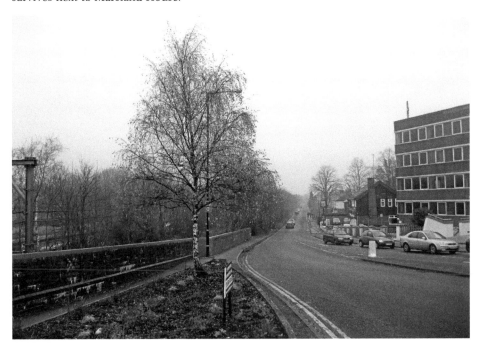

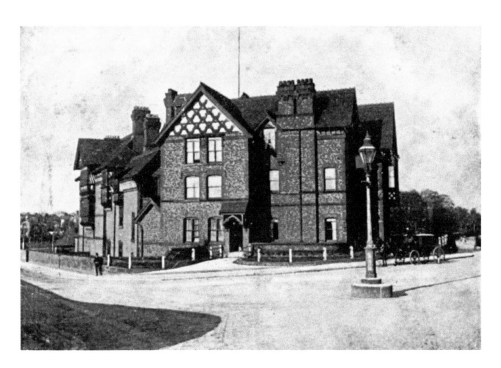

The Brooklands Hotel, at the Junction of Marsland Road and Hope Road, 1903
Built in 1872 and demolished in 1972, to make way for offices at Marsland House, it was owned by the Grand Hotel in Manchester and used as an annexe. In 1893 the Brooklands Agreement was signed here, between the Federation of Master Cotton Spinners' Associations and the Operative Cotton Spinners. This was the first agreement between capital and labour in the cotton industry. In 1947 it is believed that famous comedians Laurel and Hardy stayed in the hotel.

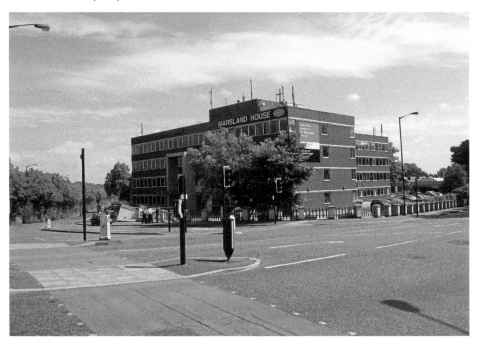

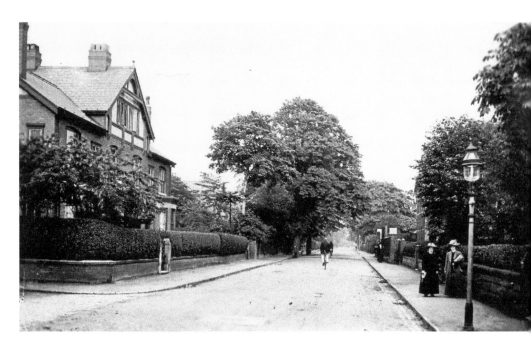

Poplar Grove, at its Junction with Melrose Avenue, 1912

The two trees in the centre of the 1912 photograph would appear to be located at the edge of the roadway and not the pavement. It is probably these two trees which give the road its name of Poplar Grove. However, it is not surprising that by 2012 they are no longer situated here. There is also a particularly fine example of a gaslight in the foreground of the 1912 image, replaced by its modern equivalent 100 years later.

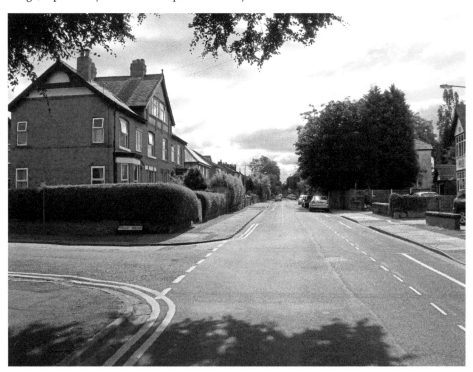

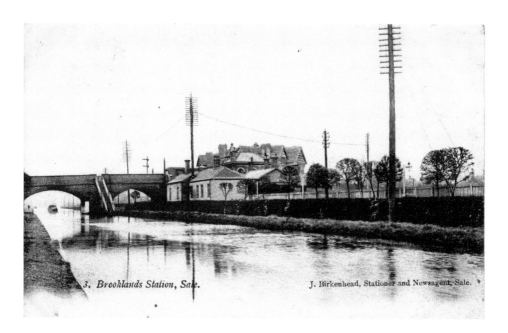

3. *Brooklands Station, Sale.* J. Birkenhead, Stationer and Newsagent, Sale.

Brooklands Station and the Bridgewater Canal, at the Junction of Marsland Road and Brooklands Road, 1903

Brooklands station was opened on 1 December 1859, by the Manchester, South Junction & Altrincham Railway. The station is Grade II listed and was constructed and named following the influence of Manchester banker, Samuel Brooks, who sold the site to the railway company. The 24 December 1991 was the last day that British Rail electric trains ran this route, which reopened on 15 June 1992 as a Metrolink tramline. The tower in the 2012 photograph houses a lift.

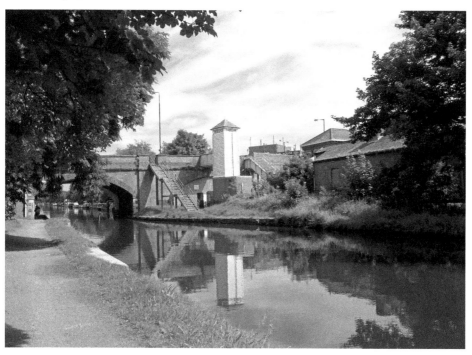

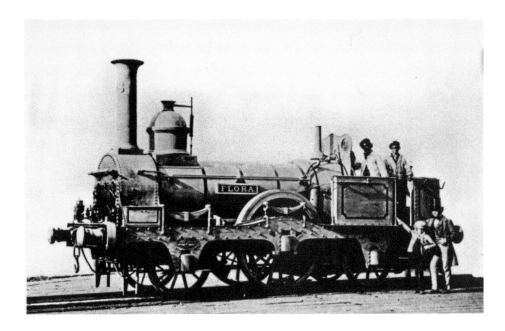

Flora at Manchester, South Junction & Altrincham Railway, 1849, and Metrolink Tram, 2012
Flora, engine number seventy-eight, was originally built in 1849 by Sharp Brothers & Co. of Manchester. She was the first engine to run the Manchester, South Junction & Altrincham Railway, when it opened in 1849. By 2012 Metrolink trams are running the service between Manchester and Altrincham. The original Metrolink fleet of 1992 is to be replaced by yellow and silver M5000 Flexity Swift trams, photographed here at Sale and first introduced at the end of December 2009.

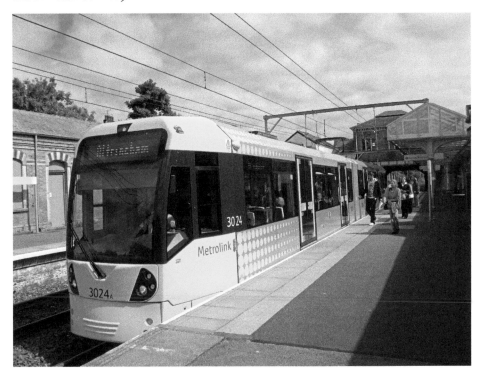

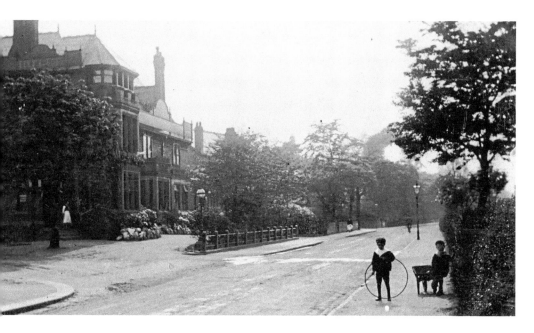

The Sale Hotel, Marsland Road, 1900

Built in 1879 as part of Moorfield Gardens – later Sale Botanical Gardens – Sale Hotel rivalled Manchester's Belle Vue and Pomona Gardens. They included a ballroom, a lake, a cycle track and grass tennis courts, closing in 1896. The tower was built as a vantage point. It is believed that the world's first pneumatic tyre bicycle race was held here, at the Manchester Wheeler's Cycle Club. Sale Hotel closed in 2009, became listed in 2010 and reopened as the Moorfield Hotel in 2011.

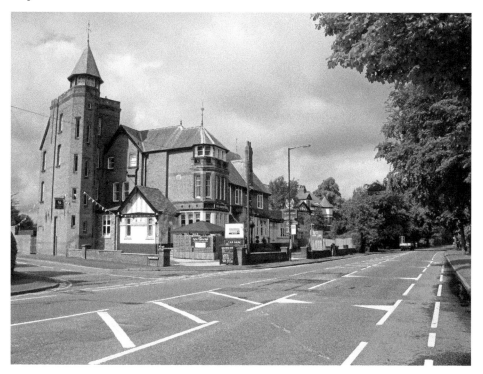

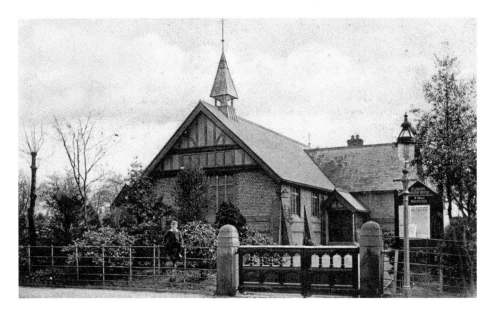

St John the Divine Parish Room, Marsland Road, 1905, and St John the Divine, Brooklands Road, 2012

Brooklands was named after Manchester entrepreneur Samuel Brooks, who purchased the land here in 1856. His church for the district, St John the Divine, was built by Manchester architect, Alfred Waterhouse, between 1864 and 1868, and opened on 9 April 1868. The church has changed little, although a small bell flèche was destroyed by fire in 1945. The church hall, just visible at the back of the 2012 photograph and built in 1968, replaced the parish room on Marsland Road.

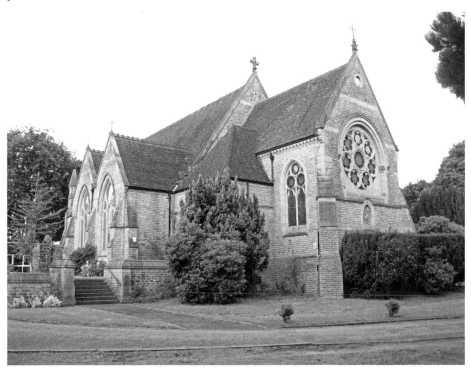

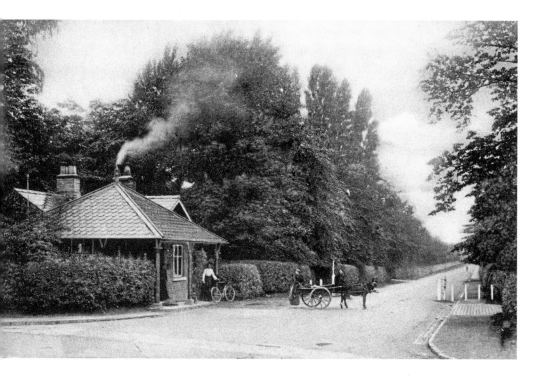

The Toll Bar at Brooklands Road, on the Sale and Baguley Boundary, 1911
Samuel Brook's original concept was the construction of a private avenue from Brooklands station, at Marsland's Bridge, and the provision of large mansion properties along it, now a conservation area. This privacy was to be augmented by a toll gate at the junction of Brooklands Road, with the former Turnpike Road connecting Altrincham and Stockport. These photographs look along Brooklands Road, towards Sale. In 2012 the gatehouse remains, although the area is now dominated by a large traffic roundabout.

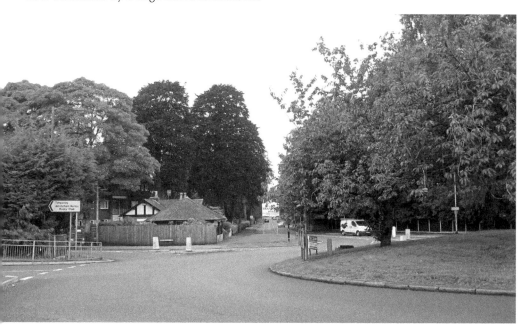

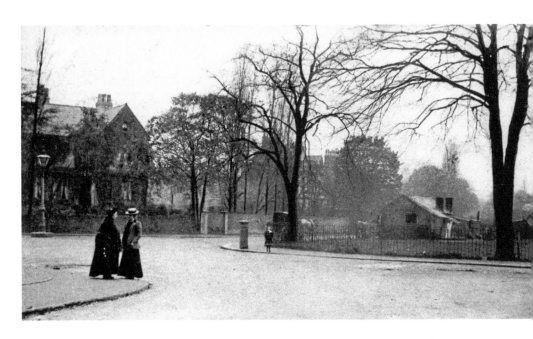

Old Hall Road, at its Junction with Broad Road and Wythenshawe Road, Sale Green, 1903
Sale Green Smithy, owned by the Yarwood family, was located close to the junction of Broad Road and Old Hall Road, in the centre of the 1903 photograph. The pillar box, also clearly visible in 1903, is behind the silver car in the 2012 photograph, although it is now set back from the corner. Until the arrival of the railway, in 1849, the centre of Sale had been at Sale Green, around Broad Road and Dane Road junctions.

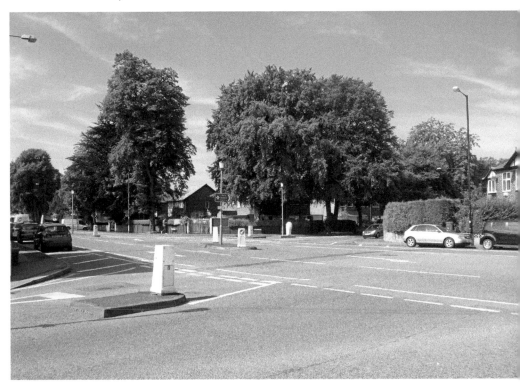

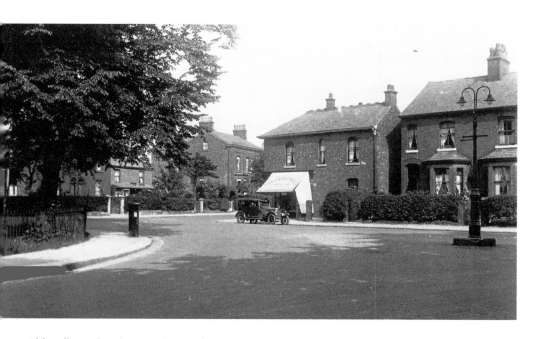

Old Hall Road, at its Junction with Broad Road and Wythenshawe Road, Sale Green, *c.* 1930
Broad Road Smithy is to the left of the 1930 photograph, with the pillar box, visible in the photograph taken from Old Hall Road's junction with Wythenshawe Road in 1903, remaining on the corner of Broad Road and Old Hall Road. There are now electric lights, replacing the gaslight, which once illuminated this junction – increased motor transport being the reason for this change. In 2012 there is still a shop, now a convenience store, at this corner.

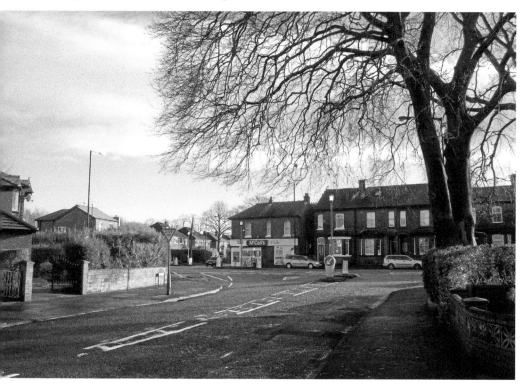

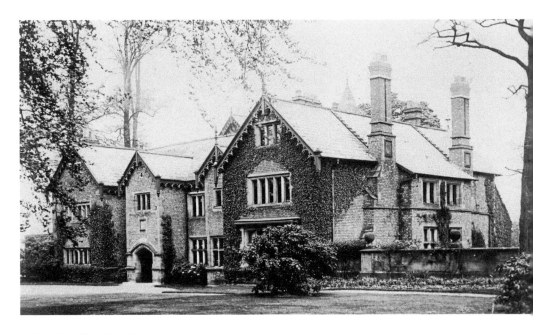

Sale Old Hall, Old Hall Road, 1900

In 1900 Sale Old Hall was the residence of Sir William Bailey, who erected the 'Togo' pagoda in its grounds. The Hall and ancillary buildings were situated on the south side of Rifle Road, at its junction with Old Hall Road. They were demolished in 1920 but the dovecote (*inset*), built in 1895, remained, later being located on a motorway roundabout. When the M60 was widened it was moved to a new location at Walkden Gardens, on Marsland Road.

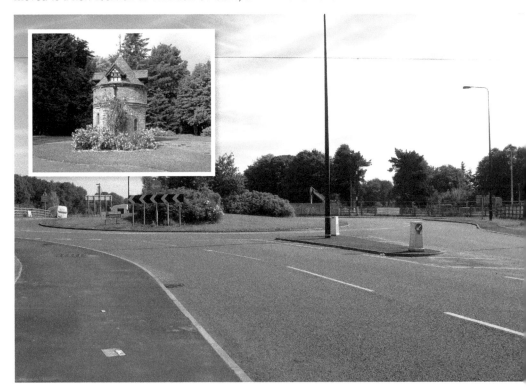

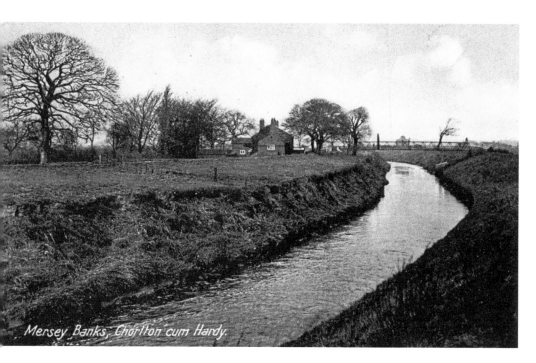

Mersey Banks, Chorlton cum Hardy.

Jackson's Boat and Footbridge, Rifle Road, Looking Towards Sale Water Park, 1910
The original building dates from 1663, with the present public house, built around 1800, incorporating some older structures. Originally known as the Bridge Inn, or Jackson's (Ferry) Boat, the ferry that used to cross the River Mersey at this point was discontinued in 1816 when a wooden bridge was built. This was swept away in a storm and replaced by an iron bridge in 1881. In the eighteenth century it was a regular meeting place of the Jacobites.

Sale New Hall, at the Junction of New Hall Road and Fairy Lane, 1920
In 1688 William Massey, of the feudal landowning family, built a house in Fairy Lane, known as Sale New Hall. It was used as a farmhouse for most of its life and was demolished in 1953. Today, its site is now covered by the M60 motorway. However, the Massey family and their historic contribution to the Sale area remain noted, as part of their family insignia consisted of a bull's head, after which the public house on Cross Street is named.

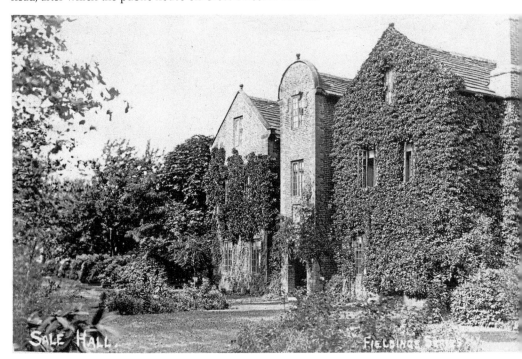

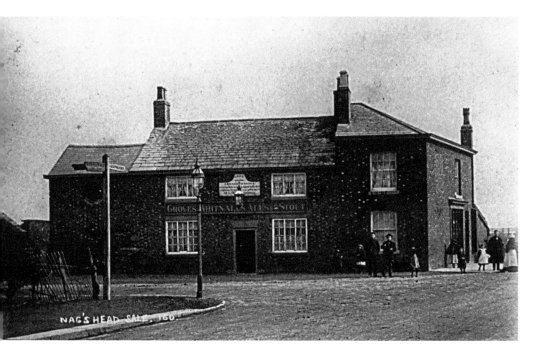

The Nag's Head, at the Junction of Wythenshawe Road and Northenden Road, 1880

The Nag's Head public house was of late eighteenth- or early nineteenth-century construction. When built, it was not originally intended to be a public house, changing its use in 1869. It was later extended by the addition of the right-hand section, which can be seen in the photograph of 1880. In 2012 only the central section of the original building remains and has reverted to its former use as a private dwelling, although the junction remains recognisable today.

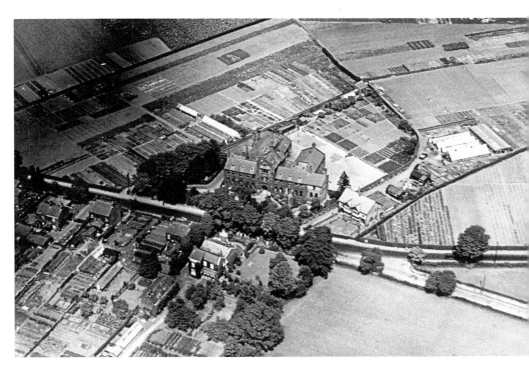

Manchester Certified Industrial School for Girls, Northenden Road, 1933
The school was built in 1876, on part of a field called Bottom High Field, which bordered Northenden Road, near the Northenden boundary, at Sale Moor. The land was offered by R. C. Browne Clayton of Chorley in 1875. The school accommodated one hundred girls and was certified on 21 April 1877. The aerial photograph of 1933 shows the Industrial School still surrounded by farmland. It was demolished in 1985, with the site now occupied by Pimmcroft Way, in 2012.

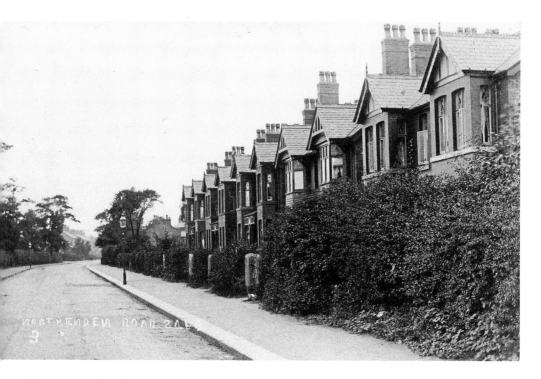

Northenden Road, Sale Moor, 1910

These suburban houses were typical middle class dwellings of the Victorian and Edwardian eras. They were situated to the east of Sale Moor, where there were no tram tracks on Northenden Road. However, this location was still close enough to Sale station and the retail amenities of Sale Moor and Sale town centre for it to be a popular place to live. By 2012 the road is wider and much busier, with traffic heading towards junction five of the M60.

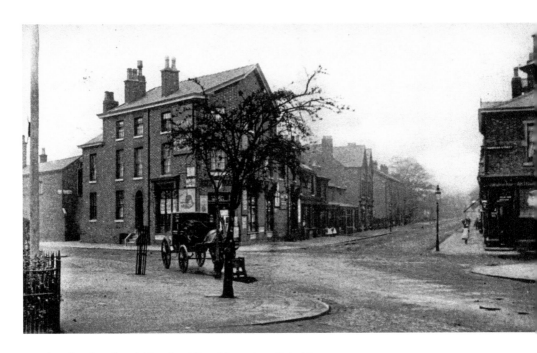

Northenden Road and Marsland Road Junction, Sale Moor, 1903

Originally belonging to Thomas Wilkinson and established in 1856, the featured retail premises were used as a general store and post office in the latter part of the nineteenth century. Those same premises, photographed in 1903, were inherited by John Wood, grocer, at 170 Northenden Road, formerly Moor Lane. Northenden Road continues straight through Sale Moor, with Marsland Road branching to the left. Today the change of business use is a sign of the times, the building currently housing a debt recovery concern.

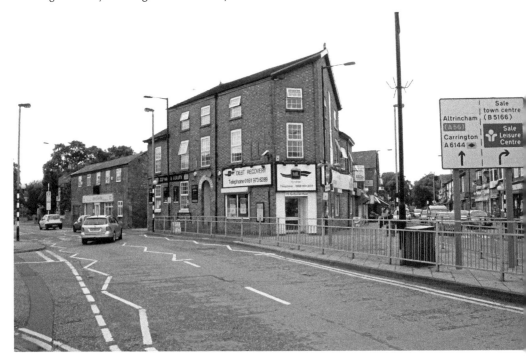

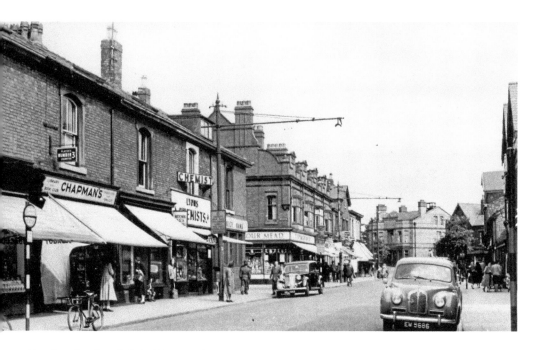

Northenden Road, Sale Moor, 1965

In 1965, Northenden Road is a typical high street, with a confectioner, a chemist and a bank, together with a selection of other stores serving the needs of the local population. In the centre of the photograph is the Legh Arms public house, a landmark in Sale Moor, which still retains some of its former Victorian character. In 2012 the diversity of retail premises remains, as does the Legh Arms, although there is an evident increase in road traffic.

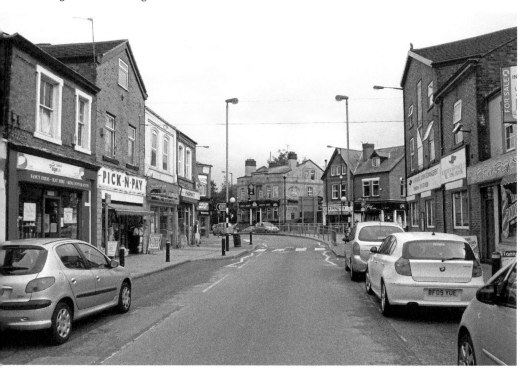

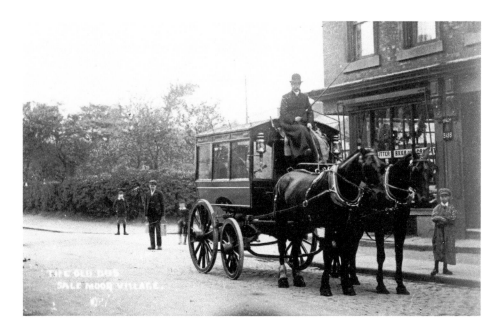

The Old Bus Outside the Temple Inn, at the Junction of Northenden Road and Temple Road, Sale Moor, *c.* 1900

By 1864 three horse-buses each day ran from Manchester to 'Sale Moor Pitts', probably similar in design to that shown in the above postcard. In the 1900s the Temple Inn premises were occupied by Jeremiah J. Wilkinson and the market garden behind the horse-bus, now a petrol station, belonged to Charles Braithwaite. According to Swain, at Temple Road's junction with Dane Road was the village Pinfold, used to confine stray livestock, until claimed by the owner.

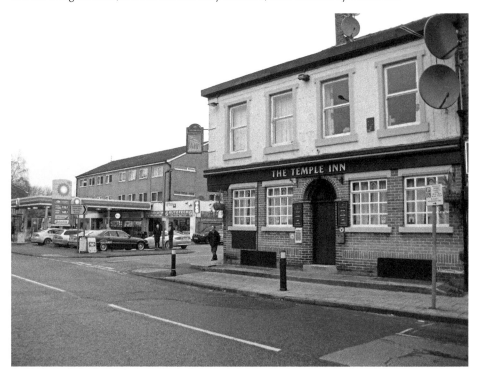

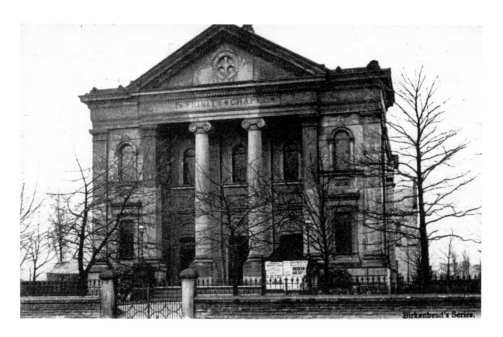

Trinity Methodist Chapel, Northenden Road, 1903

Trinity Methodist chapel opened on 30 September 1875, when the congregation from Broad Lane chapel moved into its new premises. In 1884 a new Sunday school building was added, later replaced in the 1960s by a large extension. In 1980 the main chapel building was sold and became an auction house. There were further renovations, taking place in 2006, with the main chapel building, facing Northenden Road, converted into residential flats. The chapel entrance is now in Trinity Road.

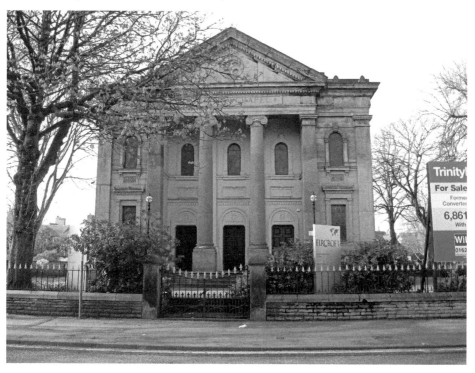

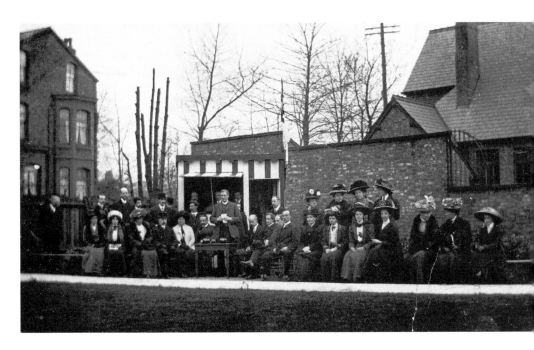

Vicar's Address on the Opening of St Anne's Bowling Green Inaugural Season, 1910, and St Anne's Church Hall, Trinity Road, 2012

St Anne's School was built in 1971, on the site of the bowling green, opened on 22 May 1909. It is adjacent to the current church hall, which was part of the original school, built in 1863 and seen in the background of the 1910 photograph. The vicar, shown standing, was the Revd John Patchett Cort, incumbent of St Anne's from 1884–1917. He was the son of the first vicar, the Revd Jonathan Johnson Cort, incumbent from 1856–84.

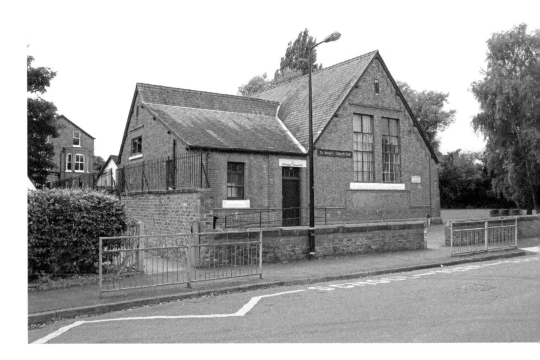

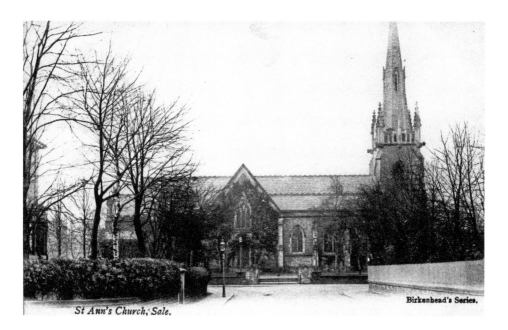

St Ann's Church, Sale.

Birkenhead's Series.

St Anne's Church, Church Road West, 1903

Today known as St Anne's, Sale, with St Francis, Sale Moor, St Anne's church opened on 14 July 1854. The church was built on a site presented by entrepreneur Samuel Brooks, who also made an initial donation to the church of £500. The architect was William Hayley of Manchester and the total cost of the building came to £4,200, nearly all raised by the voluntary contributions of Sale residents. There were further alterations and additions, made in 1864 and 1887.

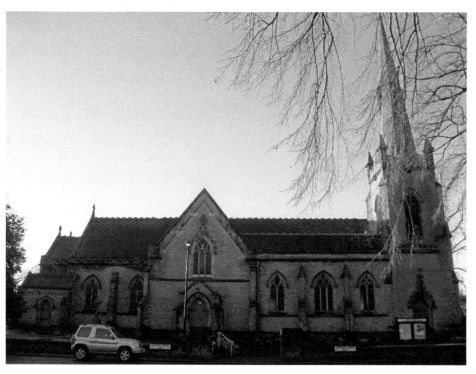

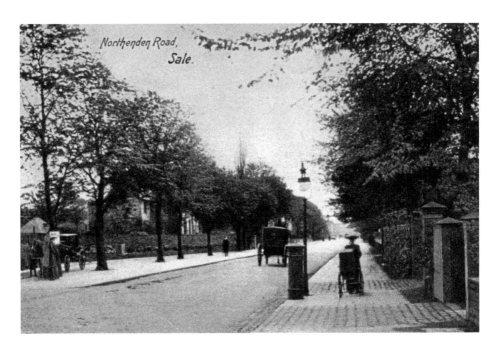

Northenden Road, Looking Towards Sale Moor, Before 1912

In 1867 Northenden Road was known as Moor Lane, at Sale station, and Hart Lane at the Northenden boundary. In 1868 the whole length was renamed Northenden Road. Sale Tramway was opened in 1906 but it was not until 1912 that the tramline was extended to the Legh Arms, in Sale Moor. Therefore, the photograph showing a horse taxi rank on the left side of Northenden Road dates from before 1912 and is still used by taxis in 2012.

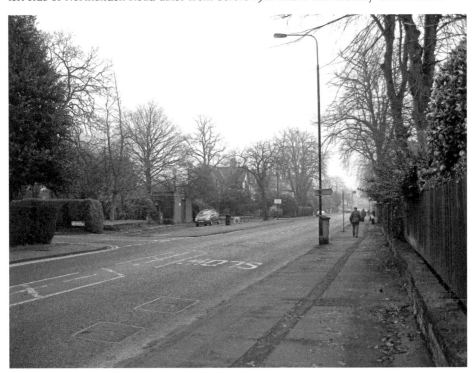

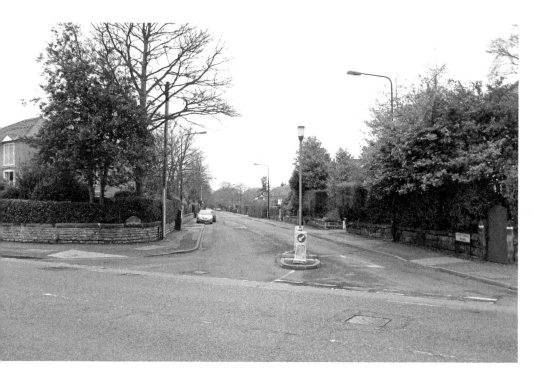

Derbyshire Road, at its Junction with Northenden Road, 1903

In the latter half of the nineteenth century the Derbyshire Road area began to develop into a comfortable suburban district. The houses on the left of the 1903 photograph have been replaced by modern flats in 2012 and on the right side of Derbyshire Road were originally the smithy and Gough's Field, which had been developed by 1903. In 2012, the junction of Derbyshire Road and Northenden Road has been widened and there is now a small traffic island here.

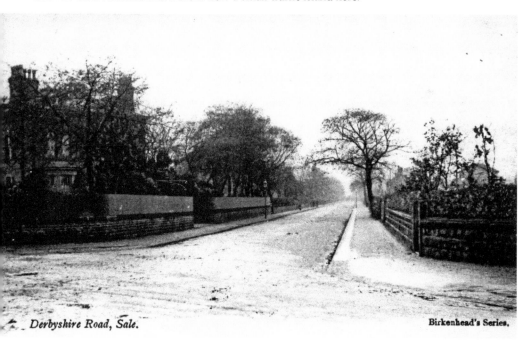

Derbyshire Road, Sale. Birkenhead's Series.

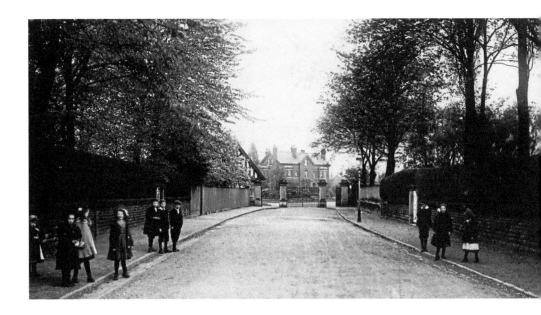

Worthington Park Gates and Lodge, Cheltenham Drive, 1911

Sale Park opened on 30 June 1900 and was renamed Worthington Park in 1949, after Mary Worthington of Sale Lodge, the widow of James Worthington, who had been a member of the Sale Local Board. Mary Worthington's initially anonymous financial donation led to the park's establishment. Two and a half thousand Sunday school children were invited to attend the park's opening. The lodge formerly housed a full-time park keeper and, according to the date stone, was built in 1898.

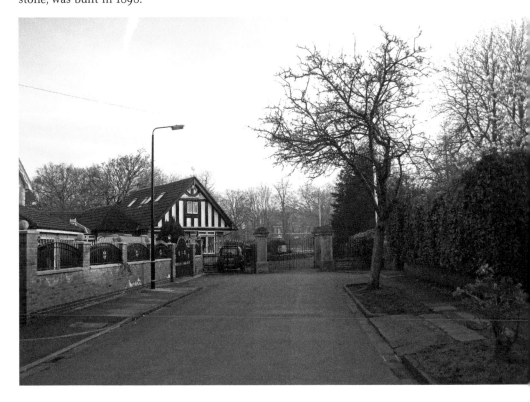

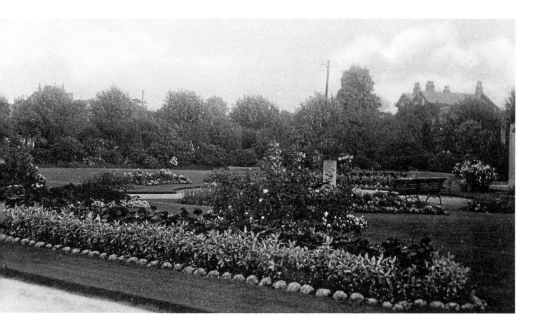

Worthington Park and the Joule Memorial, 1918, and Entrance to Worthington Park, Cheltenham Drive, 1903 (*Inset*)

Worthington Park's original facilities included a bandstand, ornamental lake and summerhouses. It covers 16.5 acres and has a memorial to Sale scientist, James Prescott Joule (1818–89), who lived for many years on Wardle Road. It was also home to a stone lion, which is now located in the Sale Waterside complex. The photograph of 1918 shows formal flowerbeds in front of the lodge, while the inset photograph of 1903 shows the lodge and flowerbeds from the opposite direction.

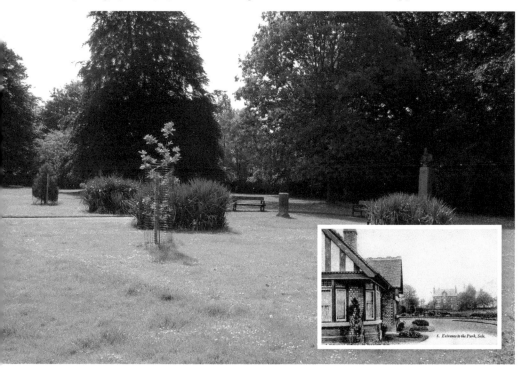

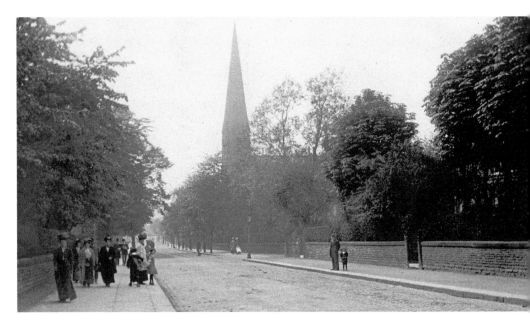

Sale Presbyterian Church, Northenden Road, *c.* 1900

Sale Presbyterian church, at the junction of Northenden Road and Woodlands Road, was built in 1874 and redeveloped in 1968. The distinctive church spire may have gone but the two red Cheshire sandstone window frames, which were visible high up on the old church building, have been recycled. The 'Rose Windows' now form part of the structure of Sale United Reformed church, on nearby Montague Road. In 2012 the original site of the church is now an office block.

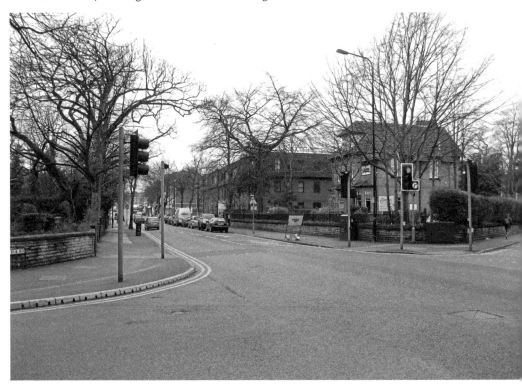

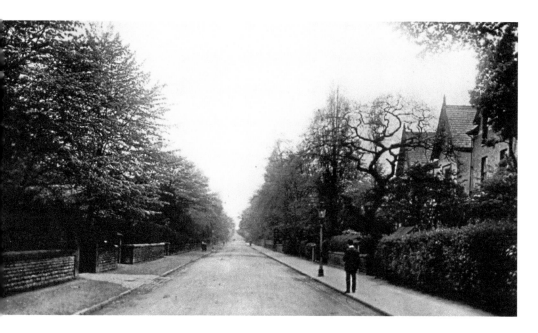

Wardle Road, 1912

Rutland House, at 12 Wardle Road and on the right of the 2012 photograph, was once the home of the famous scientist and physicist, James Prescott Joule (1818–89). He lived here for the final seventeen years of his life. Joule's theories led to the joule and the kilojoule becoming the standard measurements for energy. There is a memorial to Joule in Worthington Park and more recently a bar on Northenden Road has been named after its famous one-time resident.

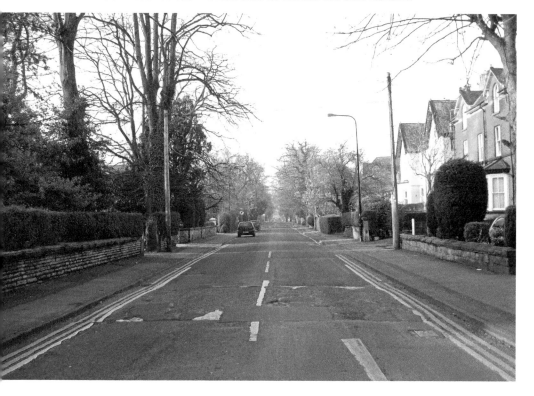

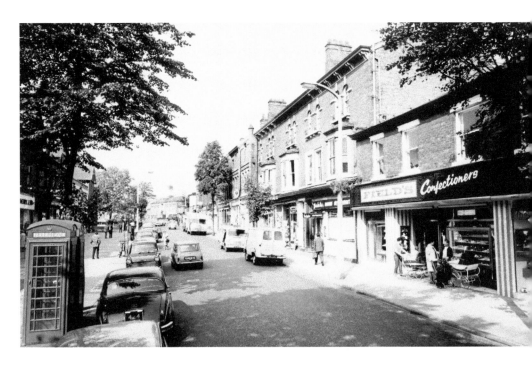

Northenden Road, Looking Towards Sale Town Hall, 1965

This section of Northenden Road does not appear to have changed a great deal. However, on comparison of the two photographs, there is now a pedestrian crossing at this point and road markings mean traffic no longer parks along this section, as it did in 1965. The two-storey shops on the right-hand side of the 1965 photograph have now been replaced by three-storey ones in 2012, and the K6 red telephone boxes have also been modernised.

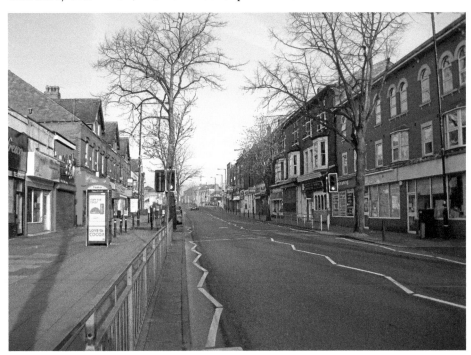

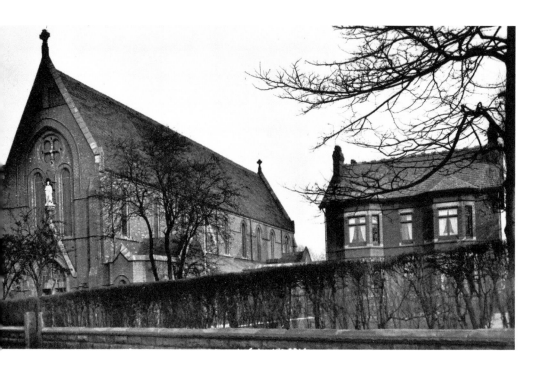

St Joseph's Roman Catholic Church, at the Junction of Hope Road and Montague Road, 1912
St Joseph's Roman Catholic church opened on 10 May 1885 and replaced an earlier Roman Catholic chapel of 1866. The church is a red-brick building, built in a style typical of the late Victorian era and was constructed in response to increased Irish immigration into the district. The parish church is at the junction of Hope Road and Montague Road, close to Sale station and Northenden Road. It has its own primary school, which was rebuilt in 1977.

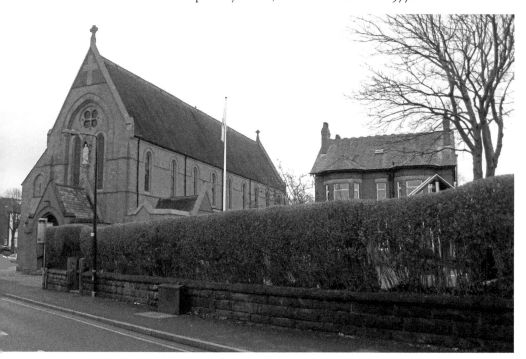

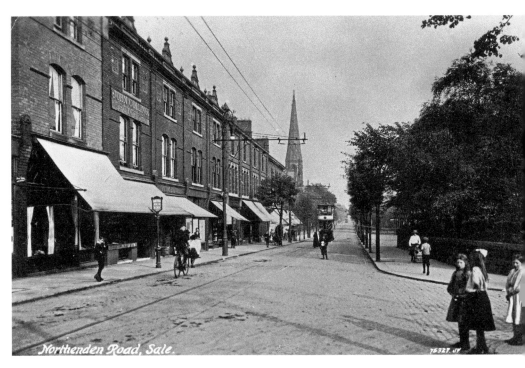

Northenden Road, Sale.

Northenden Road, as Seen from Sale Station and Hope Road Junction, 1915

Robert Oxton Bolt, CBE (1924–95), was born at 13 Northenden Road, his father's furnishing store, which is today an insurance brokerage, displaying a commemorative plaque (*inset*). Bolt wrote *A Man for All Seasons* and several screenplays, winning an Oscar for the Best Adapted Screenplay. Sale Waterside's Robert Bolt Theatre is named in his honour. Today, the retail premises of 1915 remain, with some modern development at the far end. The spire belongs to Sale Presbyterian church.

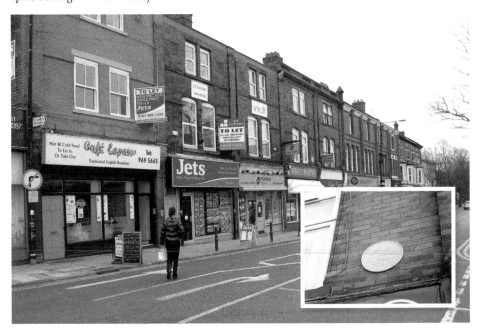

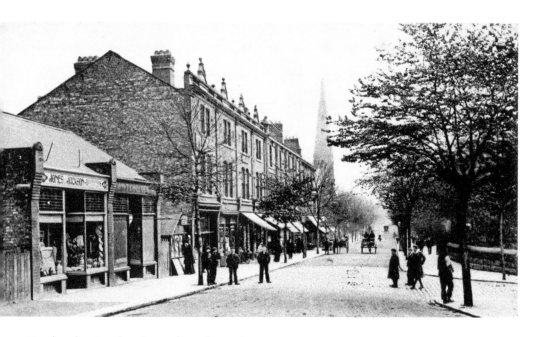

Northenden Road and Broad Road Junction, 1903

The shop sign to the left of the 1903 photograph confirms that the premises belong to Jones & Jackson, described in Slater's Directory of 1900 as 'Painters, Furnishers & Decorators and dealers in Japanese goods, & c, & c. Show Rooms: 3 Northenden Road, Sale.' The 2012 photograph shows that the buildings of the former Jones & Jackson remain, although the original woodyard is now a bar and live music venue, with traffic lights at the junction of Broad Road.

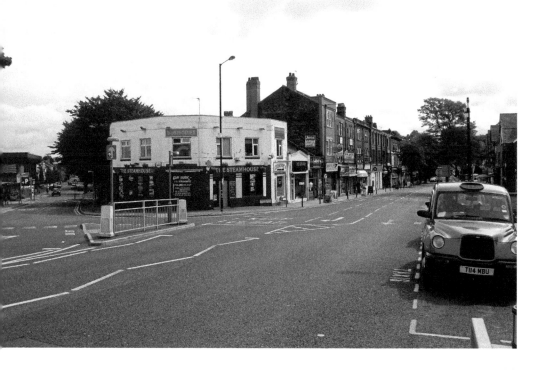

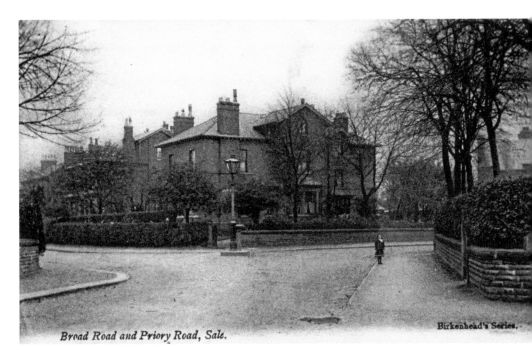

Broad Road and Priory Road, Sale.

Broad Road and Priory Road Junction, 1903

Sale historian Norman Swain believed that when the Bridgewater Canal was originally constructed, it is likely the course of Broad Lane (Road) was changed, as the sharp turn at Priory Road, in order to meet the canal bridge, looks artificial. Broad Lane probably continued to Cross Street before the 1760s. Broad Road housed Sale Baths and later Sale Leisure Centre, which officially opened on 25 July 1973. The inset photograph, taken from the same location in 1922, looks towards Sale.

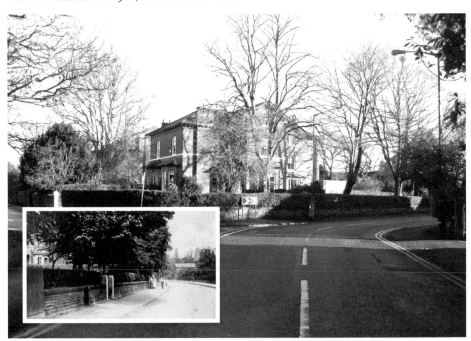

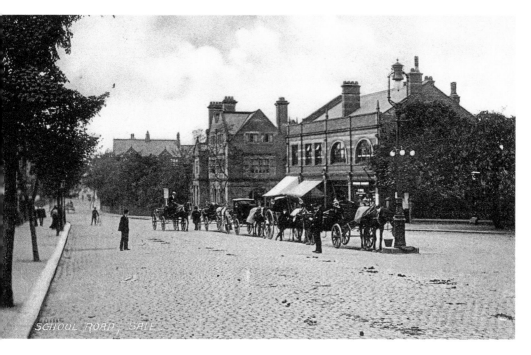

Lloyds Bank and Horse Taxi Rank, Corner of Tatton Road and School Road, *c.* 1902

The building in the centre of the photograph, dating from around 1902, was Lloyds Bank, which remains virtually unchanged in 2012, although it is now a solicitor's premises. The shop premises, known as Tatton Buildings and located to the right of Lloyds Bank, now form part of Sale town hall, which officially opened in 1915. The horse taxi rank served commuters using Sale railway station and retail premises along School Road. In 2012 there is still a taxi rank outside Sale Metrolink station.

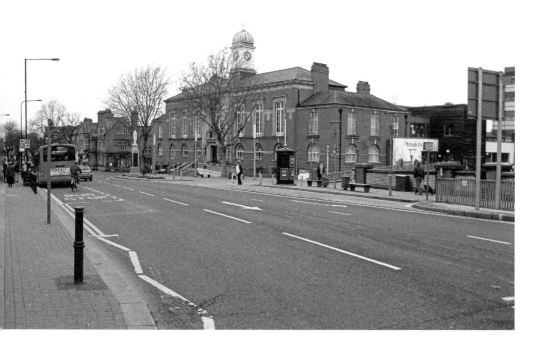

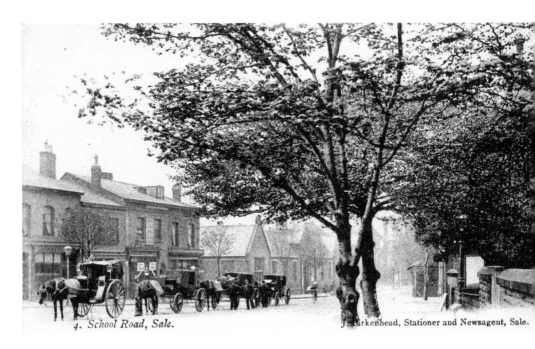

4. *School Road, Sale.*

J. Birkenhead, Stationer and Newsagent, Sale.

Sale Township School, at the Junction of Springfield Road and School Road, 1903
The entrance to Sale Township School overlooked School Road. Its distinctive bell tower and three gable ends are just visible through the trees in 1903. Springfield Road School replaced it in June 1907 and in 2012 the site is a bank. The noticeboard directly ahead belongs to the original Sale town hall, set back from School Road and rebuilt in 1915 on the same site. Sale market and fire station occupied part of this site for a time.

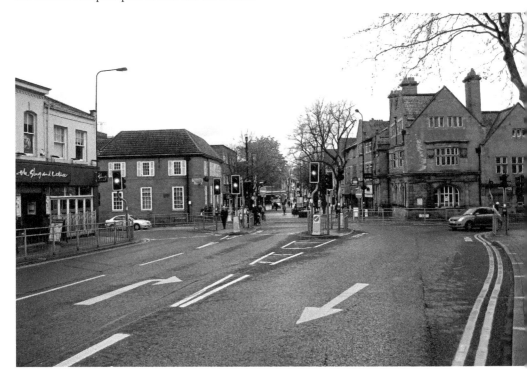

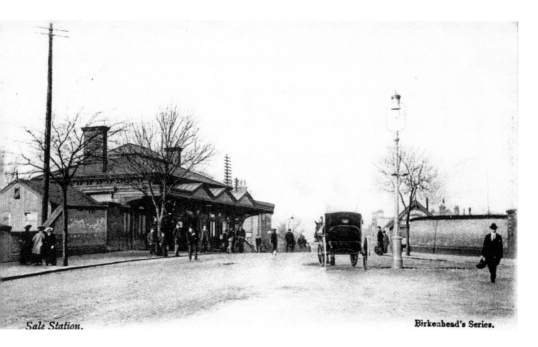

Sale Station. Birkenhead's Series.

Sale Station, as Seen from Northenden Road, 1903

Opened on 20 July 1849, as the Manchester, South Junction & Altrincham Railway, with *Flora* the first engine working this route. John Brogden of Sale built the Manchester–Altrincham section. The station, renamed Sale Moor in 1856, was rebuilt from 1874–77, replacing a wooden building. It became Sale and Ashton on Mersey in 1883 and Sale in 1931, when electric trains were introduced. It closed on 24 December 1991, reopening as a Metrolink station on 15 June 1992.

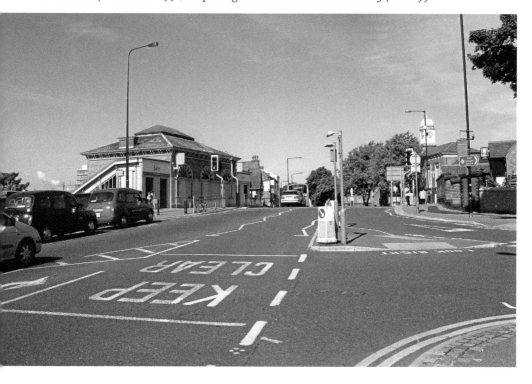

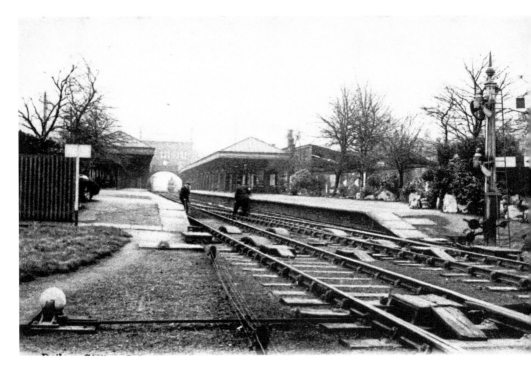

Sale Station, Looking Towards Manchester, 1903
In 1903 two things are immediately apparent about the interior of Sale station. The first is that the length of working platform is much greater in 1903 than in 2012, probably because demand was also greater and trains, therefore, were longer than Metrolink trams of the twenty-first century. The second is that the station and its gardens are immaculately kept. In 2012 the buildings along each platform are 'shells', staff not being necessary for an automated system.

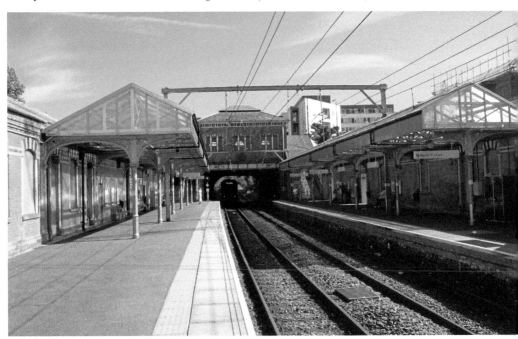

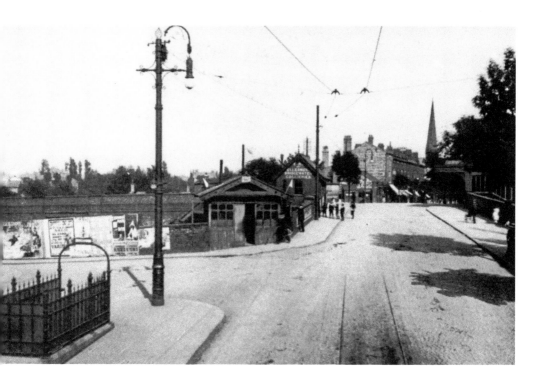

Sale Bridge, School Road, 1912

Until 1912 the buildings on Sale Bridge, seen in the centre of the photograph, served as the terminus for trams heading into Sale. After 1912 the bridge was widened and the tramline was extended along Northenden Road and into Sale Moor. Both photographs show Chapel Road to the left and Northenden Road straight ahead. In 2012 there is a bus stop and a taxi rank along this section of road, as well as traffic lights and a pedestrian crossing.

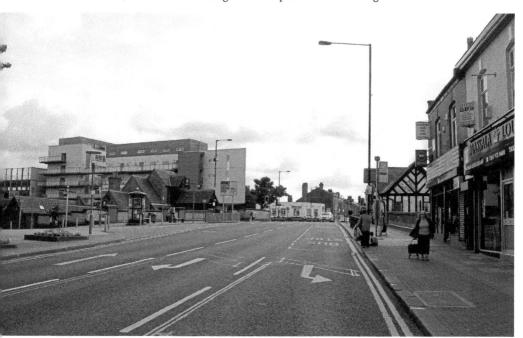

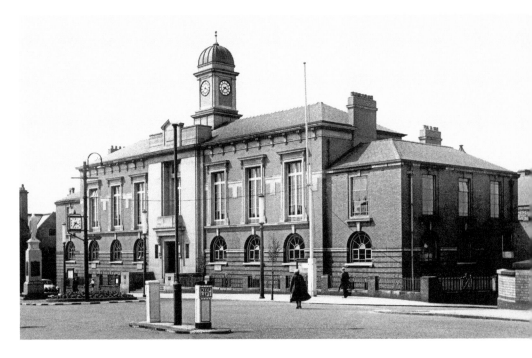

Sale Town Hall, School Road, 1955

The foundation stone of Sale town hall was laid in May 1914, with the official opening in December 1915. The town hall was badly damaged during the 'blitz' on Manchester, on the night of 23/24 December 1940, and was not fully repaired until 1952. It was extended in 1939–40 and again in 2003. The cenotaph, in front of the town hall, was located on a traffic island in 1955 but has since become part of a widened pedestrian walkway.

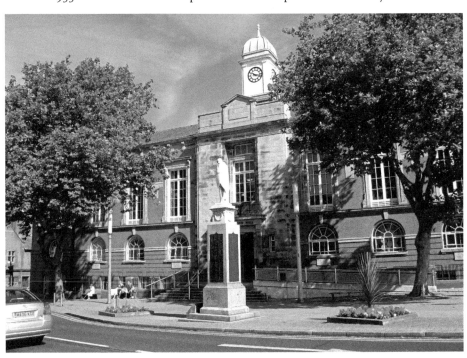

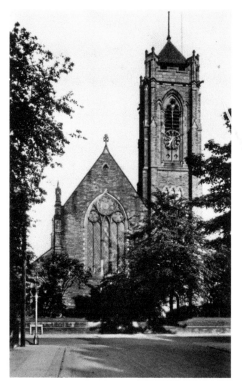

St Paul's Church, Springfield Road, 1957
St Paul's church was opened in 1883 and consecrated in 1884. It provided seating for 700 worshippers and served the growing communities of the newly developed area surrounding the church. In 1910 the church tower was constructed. However, like Sale town hall, St Paul's church was badly damaged by bombing raids in the Second World War. It is now fully restored to its former state and benefitted from the exterior being cleaned of its grime in 1972.

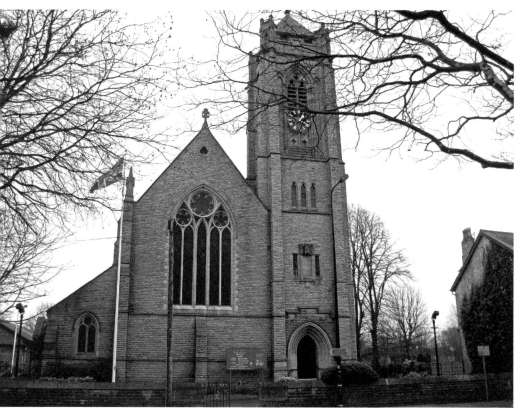

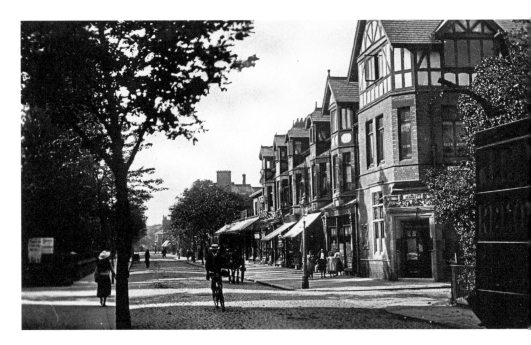

School Road, at its Junction with Claremont Road and Stanley Grove, 1915
School Road's junction with Claremont Road is on the right of the photograph of 1915, which looks towards the junction of Washway Road, Cross Street and Ashton Lane. Stanley Grove is on the left, opposite Claremont Road. The row of shops on the right originally housed Boots the Chemist and WHSmith, both businesses still trading in Sale today. In 2012 there is no trace of the original School Road, which is now completely given over to pedestrians.

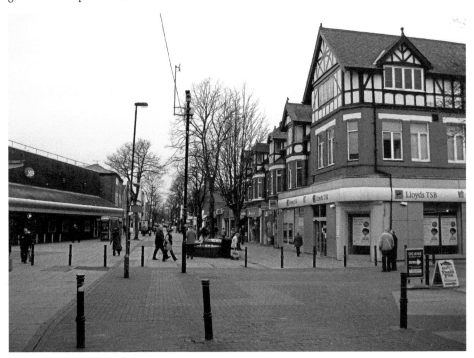

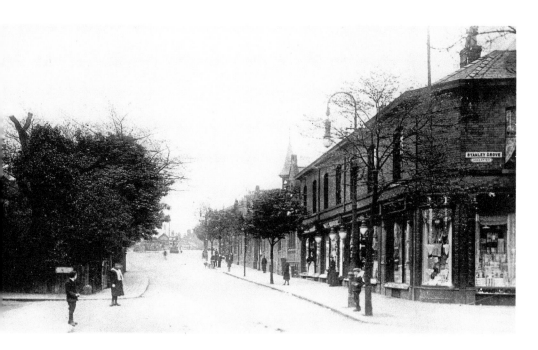

School Road, at its Junction with Claremont Road and Stanley Grove, 1913
The photograph of 1913 shows Claremont Road junction on the left, looking towards Sale Bridge. In the distance is a tram, heading for Northenden Road and Sale Moor, with a passenger about to board at the tram stop located on the bridge. Stanley Grove, on the right, was redeveloped in the 1960s, as was the Wesleyan chapel, which stood here. The modern buildings on the right of the 2012 photograph now form part of the entrance to Sale Shopping Mall.

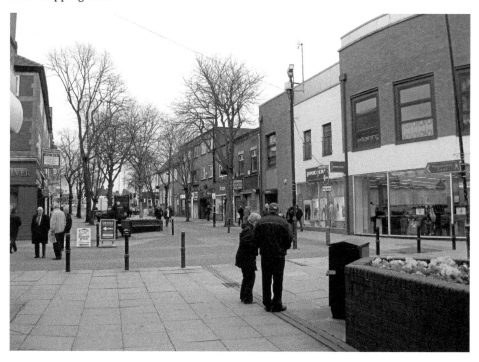

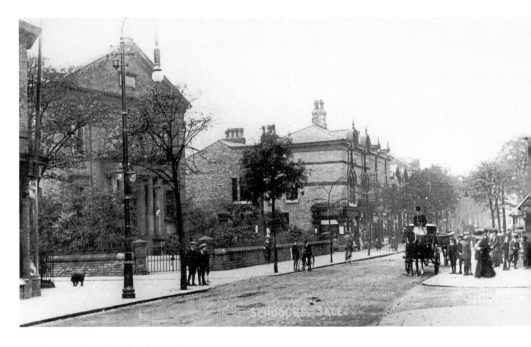

Wesleyan Chapel, School Road, *c.* 1890

Wesleyan Methodism became more popular in northern England during the second half of the nineteenth century. This lead to the Church of England embarking upon a church building programme, designed to counter the rise of Nonconformity. The Wesleyan chapel was built in 1860 and demolished in the late 1960s, its worshippers removing to a site on the corner of Wincham Road and The Avenue. It was replaced by the modern retail development shown in the 2012 photograph.

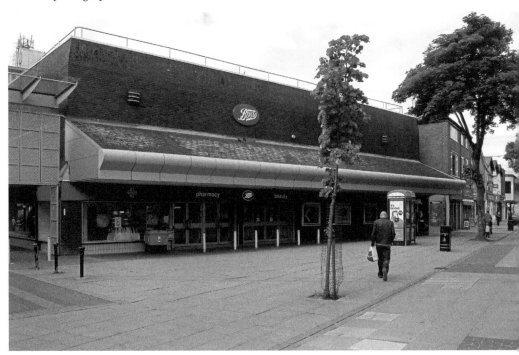

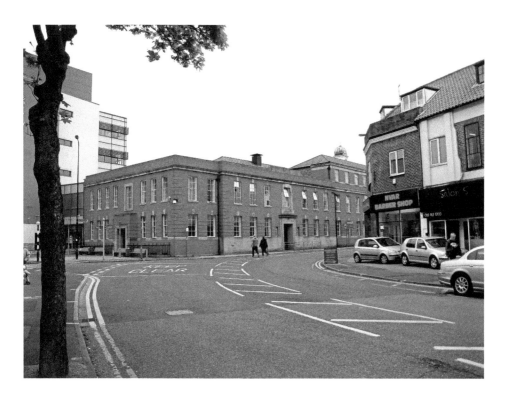

Sale Free Library and Art and Technical School, at the Junction of Tatton Road and Tatton Place, 1904

The Free Library opened in 1891, while the Art and Technical School adjoining the library opened in 1897. A cookery room was added in 1902. The front of the old library building was at the junction of Tatton Road and Tatton Place, opposite the police station, with the Technical School situated in the building to its left. In 1936 the old library was demolished, with the new building opening in 1938 and today annexed to the Sale Waterside complex.

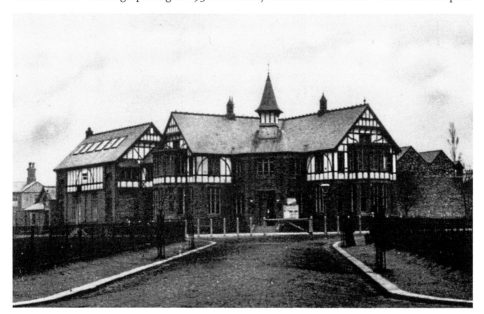

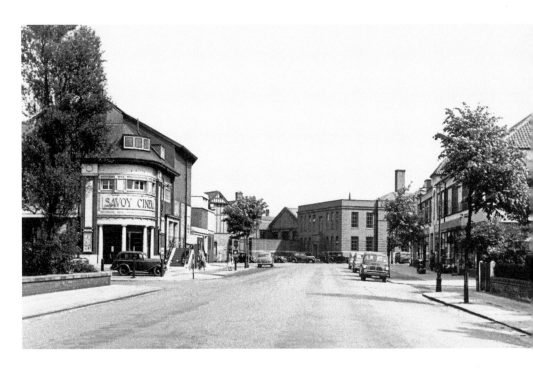

The Savoy Cinema, Ashfield Road, at its Junctions with Claremont Road and Tatton Road, 1955
In 1955 Sale Library can be seen in the centre of the photograph and together with the Savoy cinema they form the tallest buildings on Ashfield Road. However, the photograph of 2012 shows the Sale Waterside complex, opened in 2003, as a notable addition to the original library. The Savoy cinema opened in 1913, closed in February 1976, despite efforts to save it and was demolished in 1985 to be replaced by a car park, which is still used today.

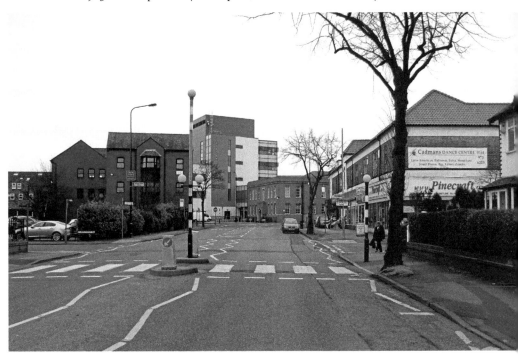

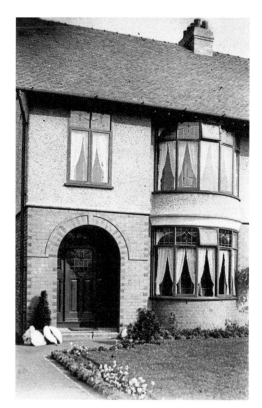

Suburban Houses, Ashton Lane and Ashfield Road, 1933

Norman Swain writes that in 1933 houses were advertised in Ashton as 'the best value in town', with detached properties £500. An advertisement (*inset*), which also appeared in 1933, announces the sale of detached houses by T. J. Rudham, as 'Value for money' at £445. The housing boom of the 1930s saw Sale described as 'one of those perfect places to choose for permanent residence'. The 2012 photograph shows T. J. Rudham's properties on Ashfield Road.

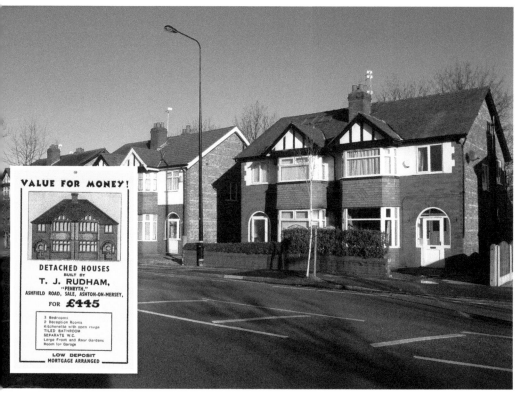

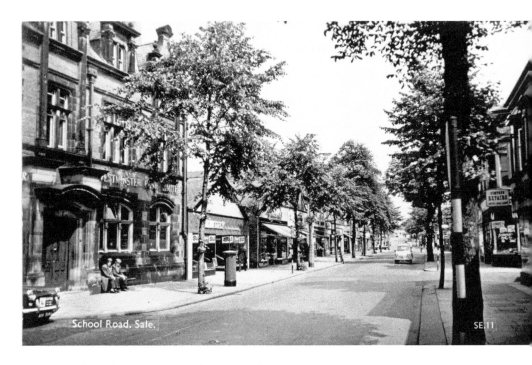

School Road, Looking Towards Sale Town Hall, 1961

The photograph of 1961 shows a clear view to the town hall and Sale Bridge. The former Parr's Bank has now become the National Westminster Bank, outside of which two gents are seated observing the photographer! In 2012 these premises have again changed hands, to become a restaurant and public house and the clear view to Sale Bridge has now been obscured by trees, raised flower beds and lamp-posts, as well as the entrance to Sale Shopping Mall.

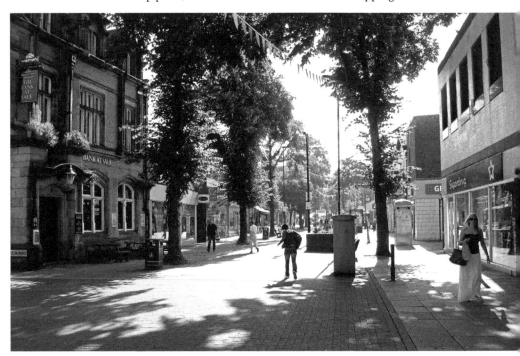

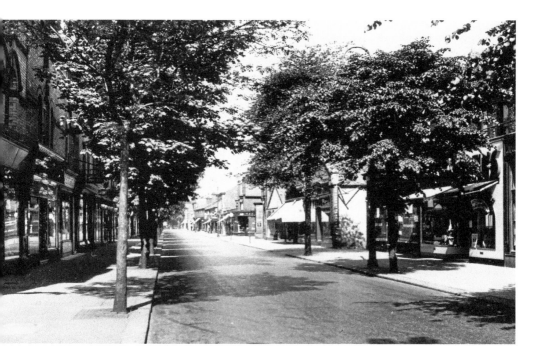

School Road, Looking Towards the Cross Street, Washway Road and Ashton Lane Junction, 1961
What is notable about the photograph of 1961 is the great number of smaller retail businesses in Sale. When compared to 2012, it is clear that the larger retail concerns have something of a monopoly. School Road was rarely traffic-free in 1961, so this photograph must have been taken early morning, or on a Sunday. In 2012, there is no clear view to the Cross Street, Washway Road and Ashton Lane junction, with benches and café frontages obscuring it.

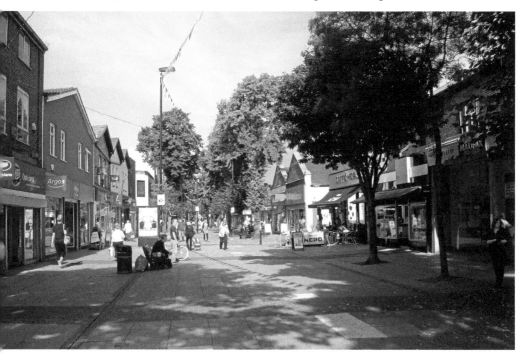

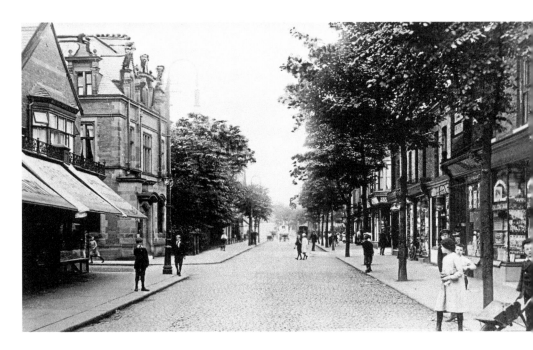

School Road, at its Junction with Curzon Road, 1919

Parr's Bank stands on the left side of School Road, at its junction with Curzon Road, in this photograph of 1919, which shows the view looking towards Sale town hall and railway station, at Sale Bridge. The roadway of 'cobblestones', or 'setts', seen in 1919, has now gone, with modern paving laid to accommodate the pedestrian. The trees are also much taller by 2012 and there is now a pillar box in the middle of what was once the roadway.

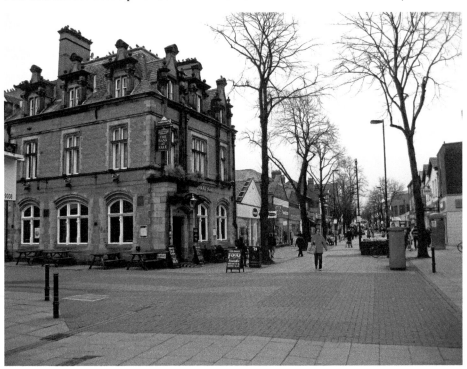

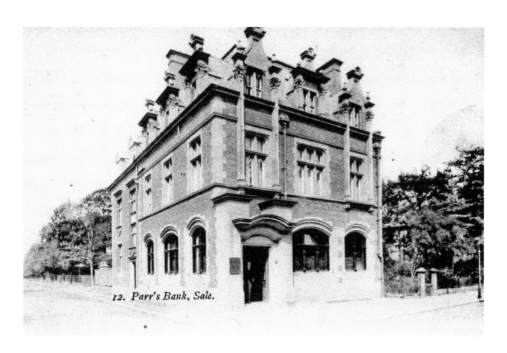

12. Parr's Bank, Sale.

Parr's Bank, School Road, 1903

At the junction of School Road and Curzon Road, Parr's Bank first came to Sale in 1874. In Slater's Directory of 1914, the manager of Parr's Bank, at 70 School Road, was listed as Robert Wall, with the presence of a banking business here emphasising the commercial importance of School Road to Sale. By the mid-twentieth century Parr's Bank had become the National Westminster Bank and is now The Bank at Sale restaurant and public house.

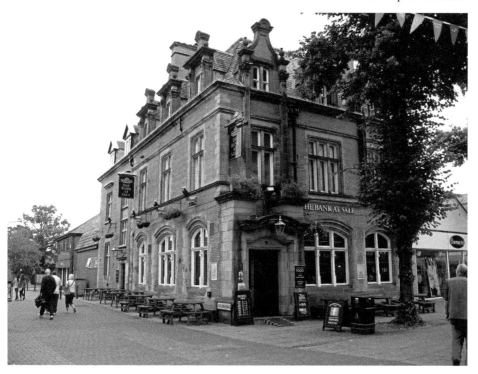

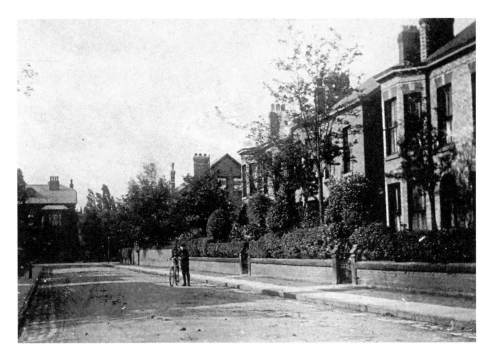

Hereford Street, School Road, 1904

In 1904 Hereford Street was a quiet residential location, while its junction with School Road experienced widespread retail and commercial development. Typical of those artisans trading here was Thomas Dickins, who was recorded as a cabinet maker and upholsterer, with works at Hereford Street, Sale, and a home address of 3 Orchard Place, School Road, Sale, in Slater's Directory of 1901. By 2012 there has been a complete transformation, with modern retail development supplanting the original Hereford Street of 1904.

Orchard Place, School Road, from Curzon Road, 1942

Orchard Place was originally constructed in 1864. Typical of its residents was the Dickins family, with three generations living here from 1864 until 1924. Today only those terraced houses closest to School Road remain, used for business and commercial purposes. The street is now a link route between School Road, Wynnstay Road and nearby car parking facilities. The 1942 photograph, taken from the window of 5 Curzon Road, shows properties on Orchard Place with front gardens that were demolished in 1955.

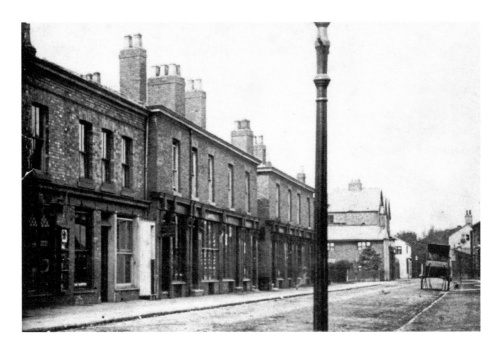

School Road, Looking Towards the Cross Street, Washway Road and Ashton Lane Junction, 1880

The building on the left side of School Road, with three gable ends, is still here in 2012. The building attached to it was demolished and a new one, without a garden, was constructed, meaning that Hayfield Street could be widened. The gaslight in the foreground is probably at School Road's junction with Orchard Place. This area of School Road has been extensively altered by modern retail development and the widening of Hayfield Street, which diverts traffic onto Sibson Road.

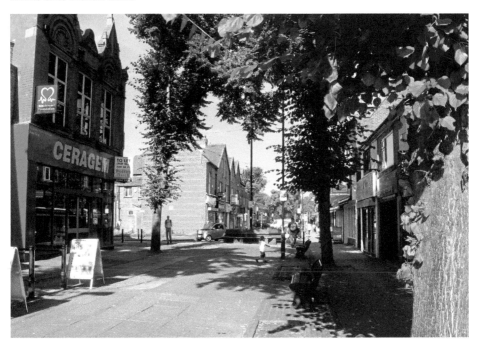

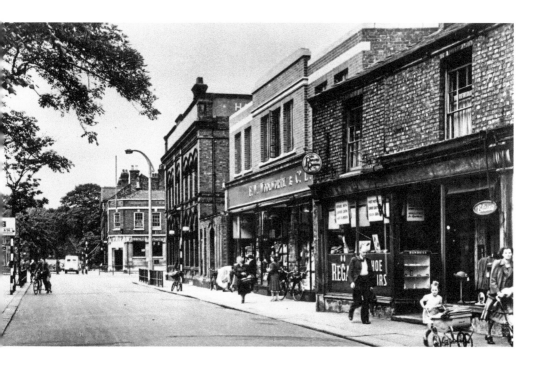

Woolworth's Store, School Road, 1950

In 1950 School Road still allowed motor traffic along its entire length and the junction of School Road, Cross Street, Washway Road and Ashton Lane was free of traffic lights. However, now Hayfield Street diverts traffic onto Sibson Road, with traffic lights controlling the safe flow of motor vehicles at the road junction. Woolworth's store is in the centre of the 1950 photograph, trading here until the 1980s. In 2012 the building is empty, having previously been Bar Amp.

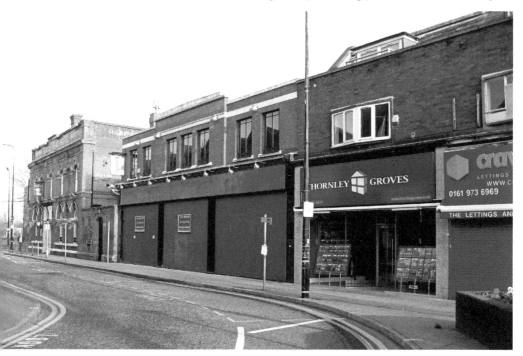

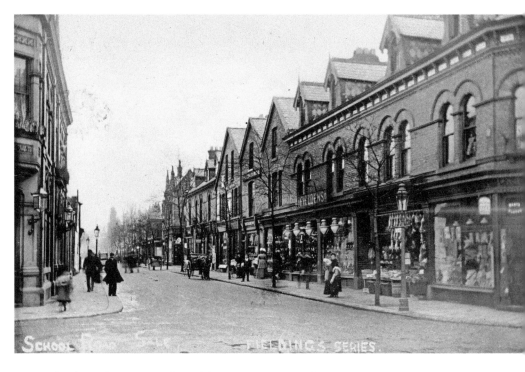

School Road, at its Junction with Cross Street, 1906
It is believed that Cross Street is named after the existence of a cross, which stood on the north end of Crossford Bridge at Stretford. At the other end of Cross Street, on the left of the 1906 photograph, is the Bull's Head Hotel, dating from 1830. It was completely rebuilt in 1879 and remains a major landmark in 2012. To the right of the photograph, School Road's junction with Hayfield Street, which leads onto Sibson Road, is visible.

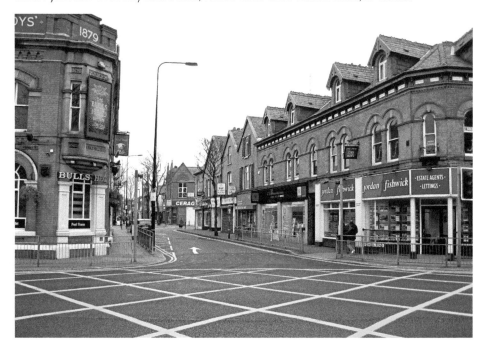

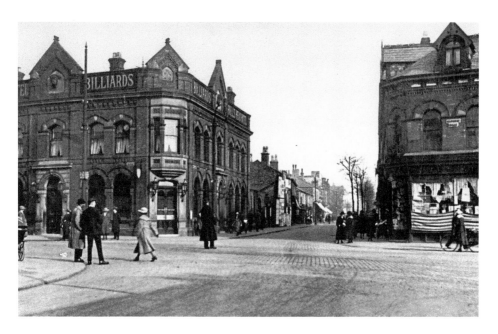

The Bull's Head Hotel, at the School Road, Cross Street, Washway Road and Ashton Lane Junction, 1920

One thing that is immediately obvious about the photographs of 1920 and 2012 is the busy nature of this particular location. Cross Street is continuous with Washway Road, formerly Watling Street, the old Roman road linking the Roman settlements at Manchester, Northwich and Chester. Today it is a major road artery, with the A56 connecting Sale to the M6, M56 and M60 motorways. It remains exceptionally busy, despite the improvements to Sale's road system in the 1960s and 1970s.

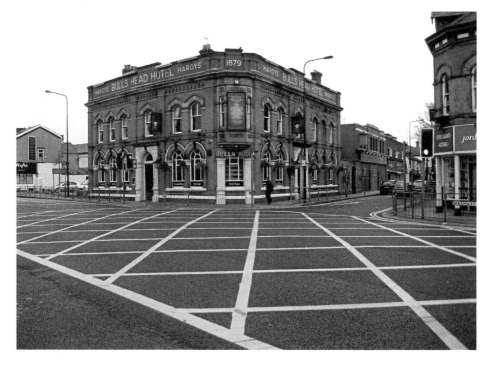

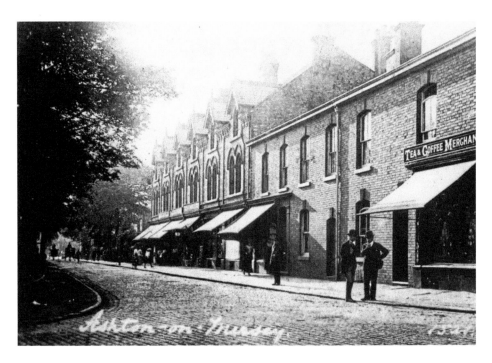

Ashton Lane, Looking From School Road Towards Ashton on Mersey, c. 1903
To the right of the photographer, on the corner of School Road and Cross Street, is the Bull's Head Hotel. The magistrates' court opposite occupies the site of John Clarke's shop, and retail premises, constructed in 1921, occupy the site of the former John Ingham & Sons, photographers, who also had premises in Altrincham in the early twentieth century. In 1903 there are no traffic lights, with all major junctions along Chester Road patrolled by police constables on point duty.

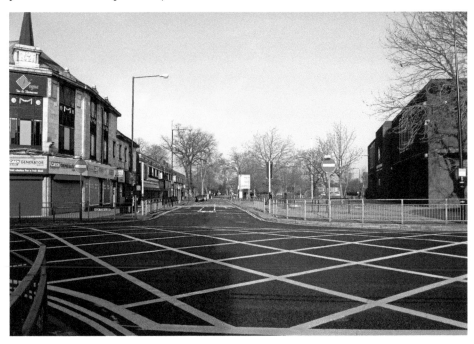

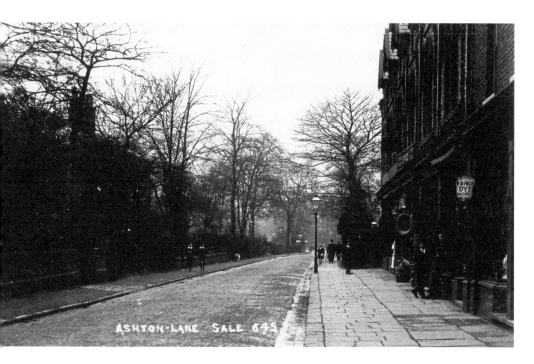

Ashton Lane Corner with Cross Street, Looking Towards Ashton on Mersey, 1905

The shopfront on the extreme right of the 1905 photograph was originally John Clarke's premises. This later became Williams Deacon's Bank which, together with surrounding buildings, was demolished in 1980 to make way for the construction of the magistrates court, opened in November 1985 by Princess Anne. The buildings on the left of the 1905 photograph were the studios of John Ingham & Sons, photographers. By 1921 they had been replaced by the retail premises shown in the modern photograph.

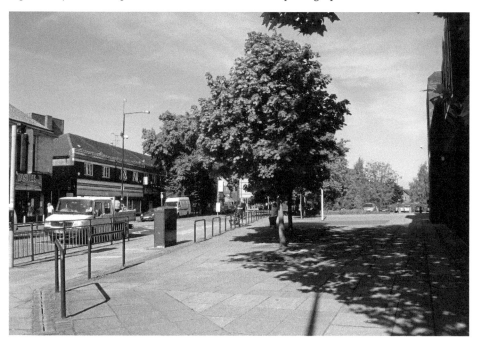

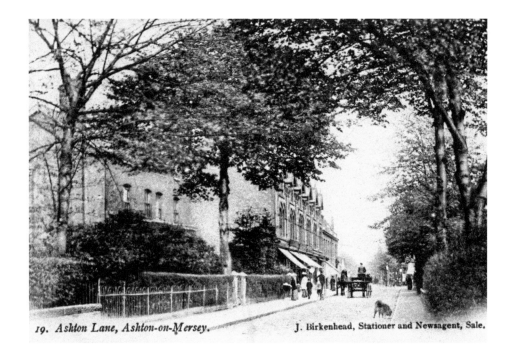

19. Ashton Lane, Ashton-on-Mersey. J. Birkenhead, Stationer and Newsagent, Sale.

Ashton Lane, Looking Towards School Road, 1903

The premises on the left of the 1903 photograph and at Ashton Lane's junction with Cross Street is John Clarke's bakery, also dealing in hardware, provisions, tea and coffee. This was a local landmark, as was John Ingham & Sons, photographers, on the opposite corner of Ashton Lane and Washway Road, at Winton House. The inset shows a *carte de visite*, *c.* 1870, by 'J. Ingham, Sale.' These were popular in the Victorian era and used as visiting cards.

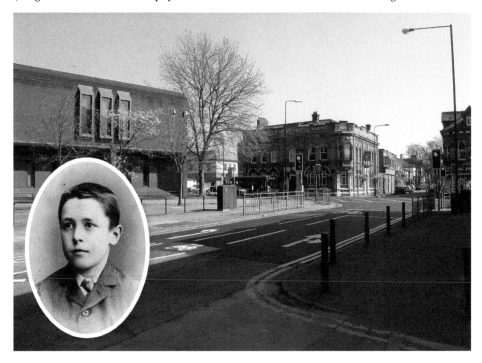

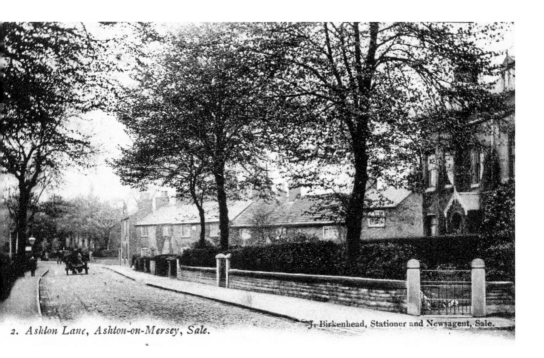

2. *Ashton Lane, Ashton-on-Mersey, Sale.*

J. Birkenhead, Stationer and Newsagent, Sale.

Ashton Lane, at its Junction with Ashton Grove, 1903

In 1903 the cottages shown in this photograph of Ashton Lane were fairly typical of the area. This view is looking towards Ashton on Mersey, with Sale Baptist church on the left. The cottages, at the junction of York Road, previously Ashton Grove, and Cranleigh Drive, were demolished in 1969, for the creation of a roundabout. In 2012, this rural idyll has been replaced by a busy road junction, designed to service the one-way system around Sale town centre.

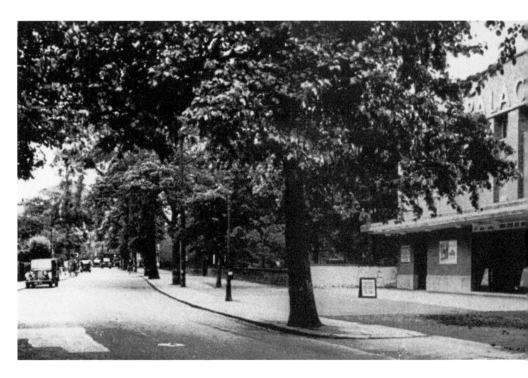

New Palace Theatre, Ashton Lane, 1959

Sale Palace, the first cinema in Sale, was originally Sale Public Hall, built around 1880. In the 1900s it was a roller rink and in 1907 became a theatre. It was known as the Palace from 1909, when films were shown there, and it was bought by Warwick Cinemas in 1947 and rebuilt in 1949. After it failed as a repertory theatre the building burnt down in 1962, losing its frontage in 1964. The site is now an office and retail development.

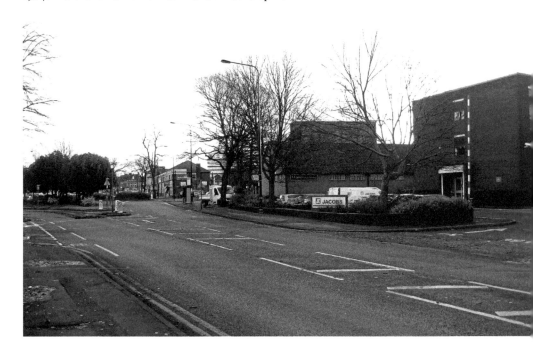

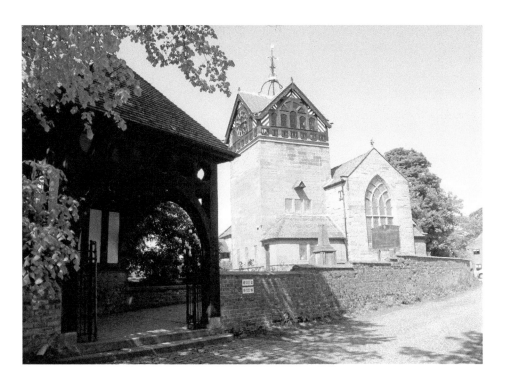

Ashton Lane and Fountain; Old Cottages, Church Lane; St Martin's Church and Lychgate; and Park Road, Ashton on Mersey, 1928

Ashton Fountain, constructed in 1881, was financed by William Cunliffe Brooks, son of Samuel Brooks, influential Sale entrepreneur and landowner. The old cottages on Church Lane once housed the curates of St Martin's church and were demolished in 1937. St Martin's lychgate, constructed in 1887, was commissioned by William Cunliffe Brooks, who also financed Brook's Institute. It has been suggested that the bottom-left photograph is Ashton on Mersey Cricket Club pavilion, destroyed by fire in 1960.

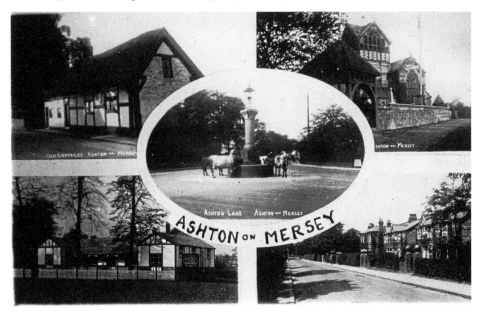

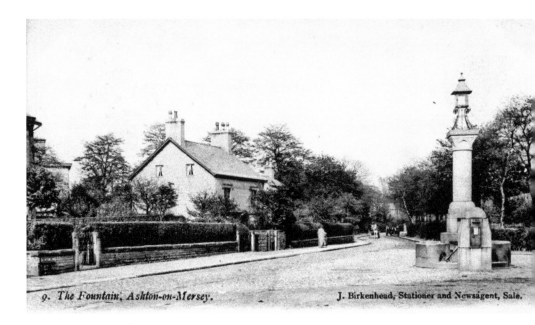

9. The Fountain, Ashton-on-Mersey. J. Birkenhead, Stationer and Newsagent, Sale.

Ashton Fountain, Junction of Ashton Lane and Moss Lane, Ashton on Mersey, 1903
In 1903 Ashton Fountain can be seen in its original condition. The fountain's gaslight provided much needed illumination at this junction and acted as a local landmark. Also, from the point of view of public utility, it served a valuable purpose as a drinking trough for horses and also held a postbox, both of which can be clearly seen in the 1903 photograph and both of which have since been removed. The cottage on the left is Newton Green House.

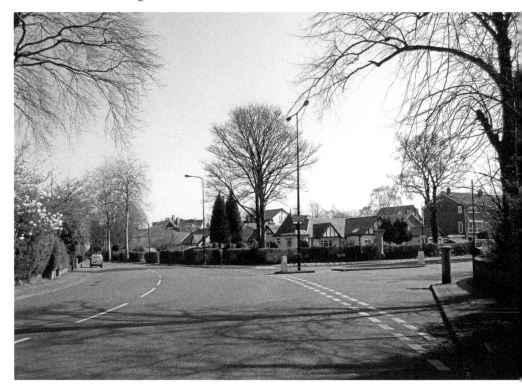

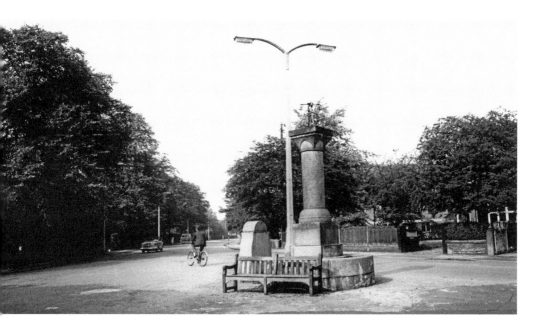

Ashton Fountain, Junction of Ashton Lane and Moss Lane, Ashton on Mersey, 1965
Ashton Fountain was erected in 1881 by William Cunliffe Brooks, at the junction of Ashton Lane and Moss Lane. It is without its gaslight, horse drinking trough and postbox, which had been moved to the left side of Ashton Lane in 1965, acquiring a bench seat instead. However, by 2012 Ashton Fountain and the pillar box have been moved to the Barkers Lane side of Ashton Lane and the fountain is without its bench seat.

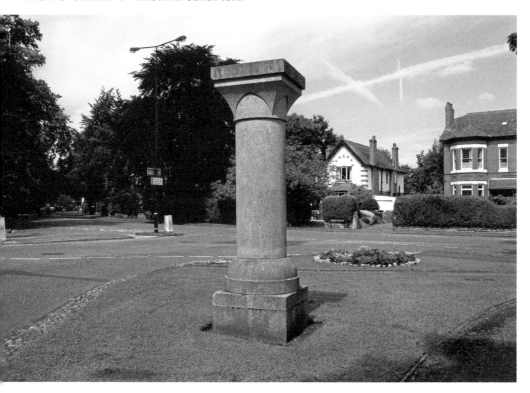

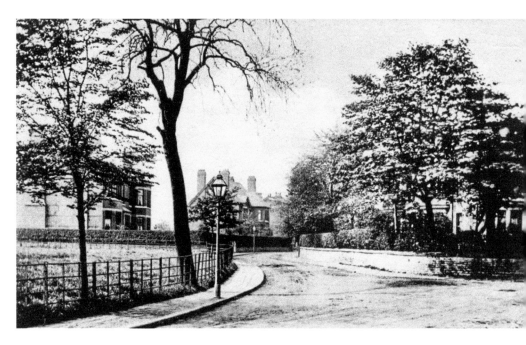

Queens Road, at its Junction with Ashton Lane, Ashton on Mersey, 1904

In 1904 much of the Ashton on Mersey side of Washway Road was still under cultivation, market gardening producing crops such as rhubarb, for which the area was well known. The village centre of Ashton on Mersey was still very much an isolated settlement. The photograph of 1904 shows the junction of Queens Road and Ashton Lane still only partially developed. By 2012 the trees here have grown and matured and suburban development is more prevalent.

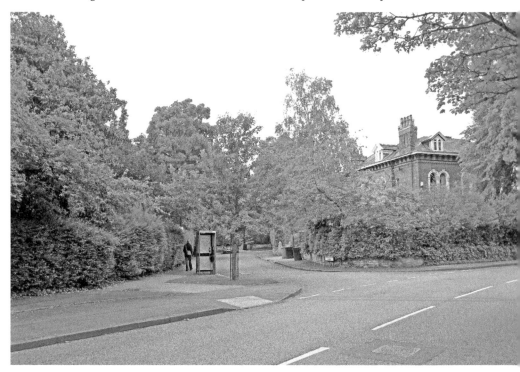

St Mary Magdalene, Harboro Road and Moss Lane corner, Ashton on Mersey, 1903

The church of St Mary Magdalene was built by public subscription, costing £9,000 in total. The land was donated by William Cunliffe Brooks, the son of influential banker and Sale landowner, Samuel Brooks. It opened on 29 March 1874, eventually becoming a parish in its own right in 1896. The church spire remains a dominant landmark at the corner of Harboro Road and Moss Lane, with the whole area north of Washway Road continuing essentially suburban and residential.

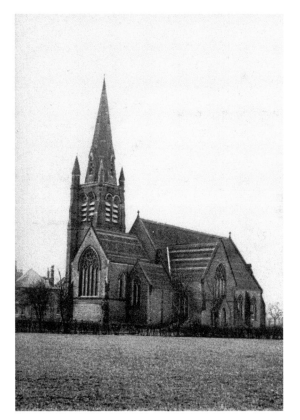

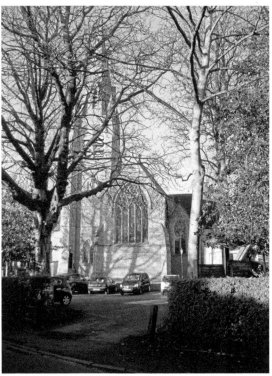

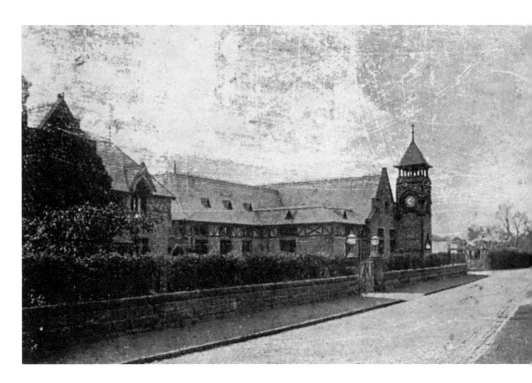

St Martin's School, Junction of Green Lane and Carrington Lane, Ashton on Mersey, *c.* 1900
Located in the centre of Ashton on Mersey, the clock tower was erected in 1874, although the school itself originally dates from 1818, when the Earl of Stamford gave the land for its construction. In 2012 St Martin's School building has changed very little from the rare postcard view of the late Victorian era. Despite the compromised quality of this photograph it can be seen that the building has maintained its main features. It is now used for commercial purposes.

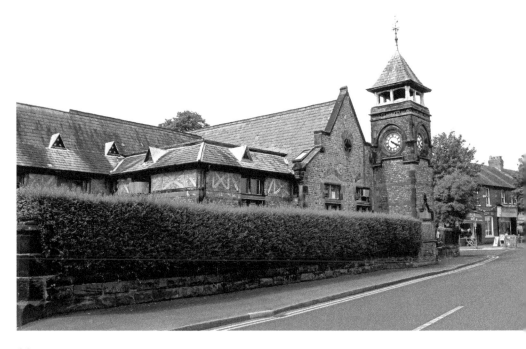

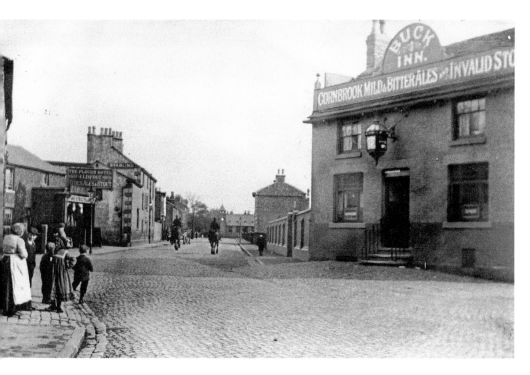

The Buck Inn, Green Lane and Ashton on Mersey Village, *c.* 1900

The Buck Inn is one of the most historic licensed premises in the district and was constructed in the early eighteenth century. It is a listed building but has not always been a public house – for a time it served as the village gaol. The stocks, now at the churchyard, were originally here and it was the venue for the court leet. St Martin's School is at the far end of the village, with the terrace on its left now rebuilt.

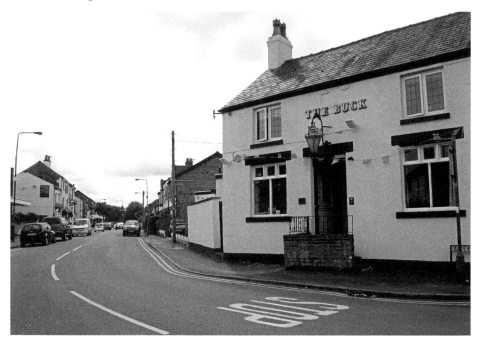

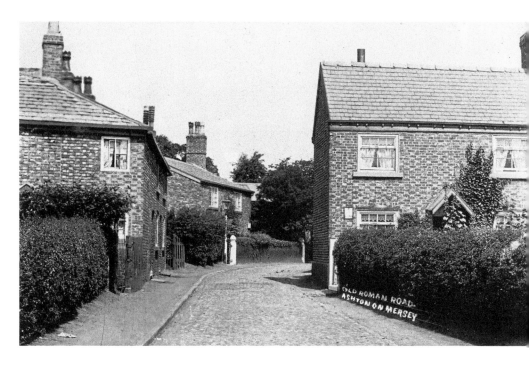

Old Roman Road, Buck Lane, Ashton on Mersey, 1911

The existence of a Roman fort in Ashton on Mersey was based on false information, fabricated by Charles Bertram who, in 1747, contacted antiquarian Doctor William Stukeley. Bertram eventually presented Doctor Stukeley with a few lines of a manuscript and a map of Roman sites, which he accepted as genuine, as did many other contemporary historians. Bertram's forgeries were not discovered until the 1860s. In 2012, the cottages on the right of Buck Lane have been replaced by modern housing.

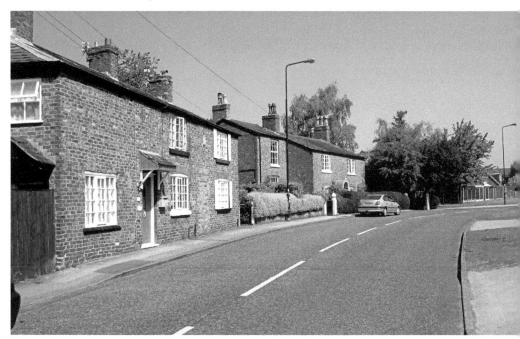

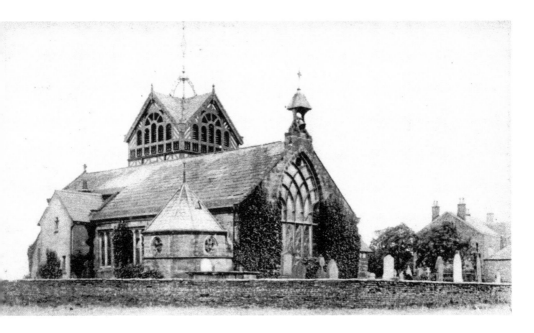

St Martin's Church, Church Lane, Ashton on Mersey, 1903

The first church was built in the late ninth century, in the time of the Saxon king, Edward the Elder. This was followed by a structure, built in 1304, by Willemus De Salle, the first rector of St Martin's, which was destroyed by a storm in 1704. A new church was built in 1714, near Ashton Old Hall, with additions in 1874 and 1886. In 1887 a new church tower, vestry and lychgate were built, designed by George Truefitt.

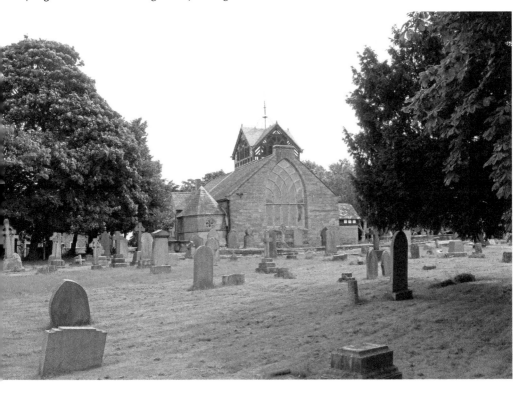

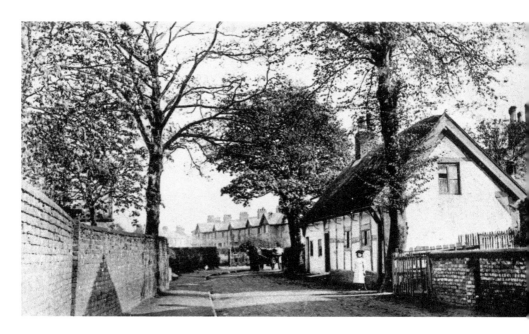

The Old Cottages, Church Lane, Ashton on Mersey, 1903

In 1937 these old thatched cottages were demolished, many years before Church Lane was declared a conservation area. Built in the seventeenth or early eighteenth century and once housing the curates of St Martin's church, by 2012 this plot has been utilised for modern housing. Some of the original buildings surrounding it remain, including the row of terraced housing shown in the background of both photographs. Brick walls, on either side of Church Lane in 1903, also remain in 2012.

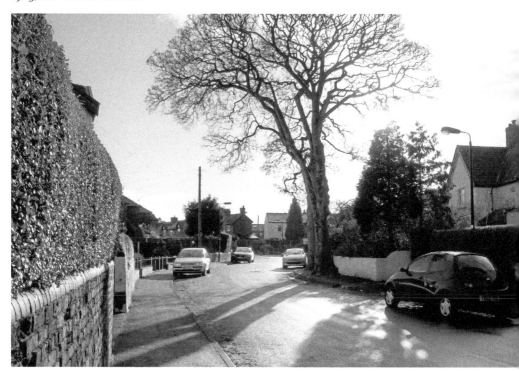

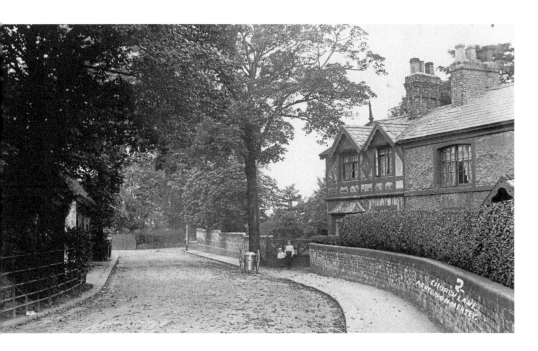

Church Lane, Ashton on Mersey, *c.* 1900

The oldest and most historic part of Ashton on Mersey, looking towards St Martin's church, with its rectory on the right corner of Church Lane and Glebelands Road. The adjacent corner of Church Lane and Green Lane is located close to Ashton New Hall and the old thatched cottage, which was once the rectory, can be seen on the left, around 1900. The cottages on the right of the photographs are little changed, despite being rendered and whitewashed in 2012.

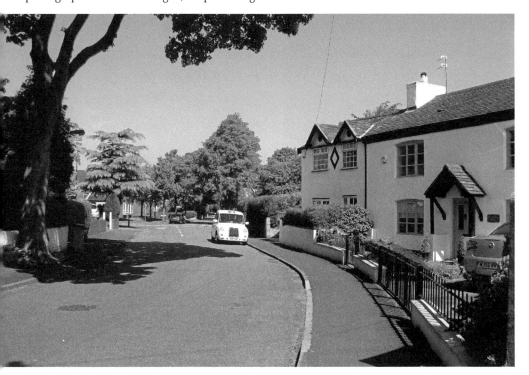

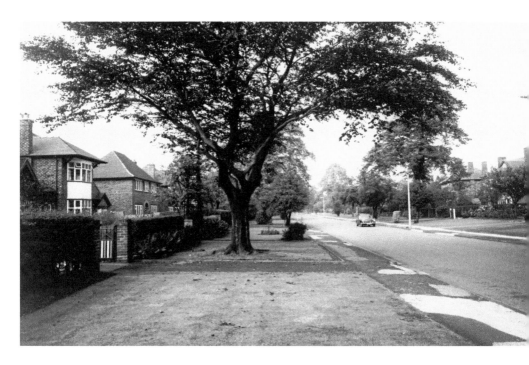

The Avenue, Ashton on Mersey, 1965

One of the most exclusive addresses in Sale, The Avenue was established by the land and property owning dynasty of Samuel Brooks and was originally known as Brook's Avenue, although there are also references to it as Woodheys Park. Oakleigh, a Victorian property, survives as apartments, but many of The Avenue's properties date from the early twentieth century, of the type shown in the photograph of 1965. Its tree-lined, straight construction is also noted in the photograph of 2012.

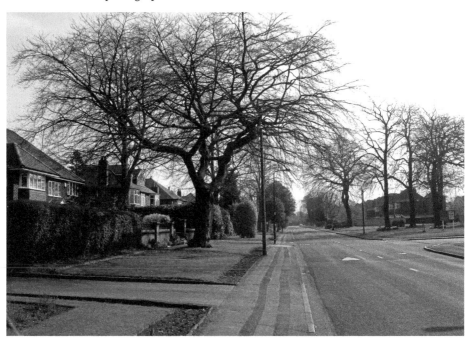

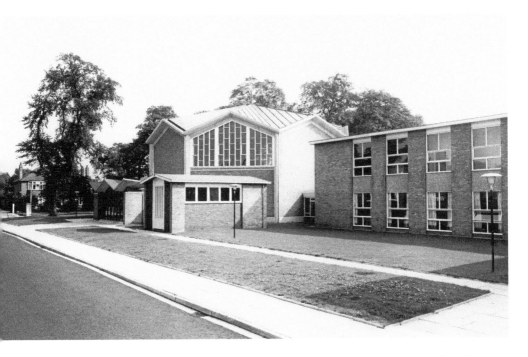

The Avenue Methodist Church, Junction of The Avenue and Wincham Road, Ashton on Mersey, 1965

On 28 September 1963 the Avenue Methodist church was officially opened by a former Vice President of the Methodist Conference, Doctor Marjorie Lonsdale. It was formed following the closure of two other churches in Sale, the Wesleyan chapel on School Road and Barkers Lane chapel. The main area of worship is octagonal in shape and designed to allow maximum use of natural light. There are ancillary buildings on two levels, with an attached church hall, redesigned and refurbished in 2009.

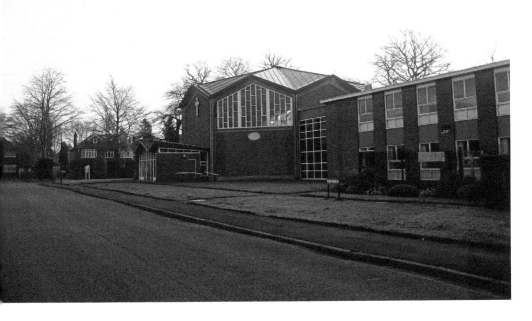

Acknowledgements & Bibliograph·

Cheshire Census Returns – Hannah Dickens, 6 Orchard Place, School Road, Sale. 1881, (RG 3506/65. No. 4) 1911, (RG14 21571) Thomas Dickins, 14 Palmer Street, Sale. 1911, (RG 21567).

Cheshire Electoral Registers – Thomas Dickins, 4 Orchard Place, School Road, Sale. 18· (883) & (1971); 1893, (888); 1894, (909) & (02096); 1894–95, (02185); 1895, (832); 18· (1156) & (02535).

Francis Frith Collection, Unit 6 Oakley Business Park, Wylye Road, Dinton, Salisbu· Wiltshire. Photographs reproduced with the kind permission of 'The Francis Fr· Collection' and 'Copyright The Francis Frith Collection'.

Hainsworth, V., *Looking Back at Sale* (Altrincham: Willow, 1983).

Kelly's Directory of Cheshire, 1896 & 1902 (London: Kelly & Co.., Ltd., 1896 & 1902).

Manchester Archives and Local Studies, The Manchester Room@City Library (Lo· Studies), Elliot House, 151 Deansgate, Manchester. Photographs reproduced courtesy Manchester Libraries, Information and Archives, Manchester City Council.

North Cheshire Family History Society – http://www.ncfhs.org.uk/ – I would like to thank t· North Cheshire Family History Society and their secretary, Liz de Mercado, for allowi· me access to their website.

Sale and Altrincham Pages. Parts One and Two – http://www.personal.u-net.com/

Sale Civic Society – salecivicsociety.blogspot.co.uk/

Sale History – www.salecommunityweb.co.uk/history.h

Slater's Directory of Altrincham, Bowdon, Sale, Brooklands& Dunham Massey, for 1899–19· (Manchester: Slater's Directory Ltd., 1899–1933).

Swain, N. V., *A History of Sale – From Earliest Times to the Present Day* (Wilmslow: Sign· 1987).

Trafford Lifetimes – www.trafford.gov.uk

Trafford Local Studies Centre, Sale Library, Sale Waterside, Sale, Cheshire – Photograp· reproduced with the kind permission of Trafford Local Studies.

This book is dedicated to my wife, Sarah, for her unfailing patience and support througho· the compilation of *Sale Through Time*.